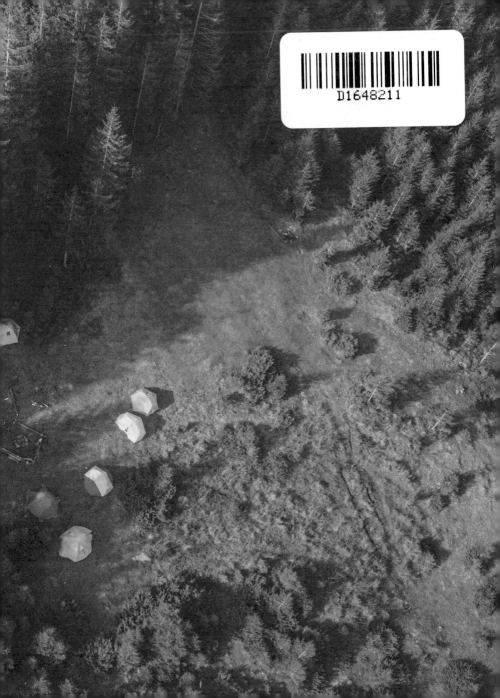

You Are Here

CAMPING

THE MOST SCENIC SPOTS ON EARTH

CHRONICLE BOOKS

SAN FRANCISCO

in association with

Blackwell&Ruth.

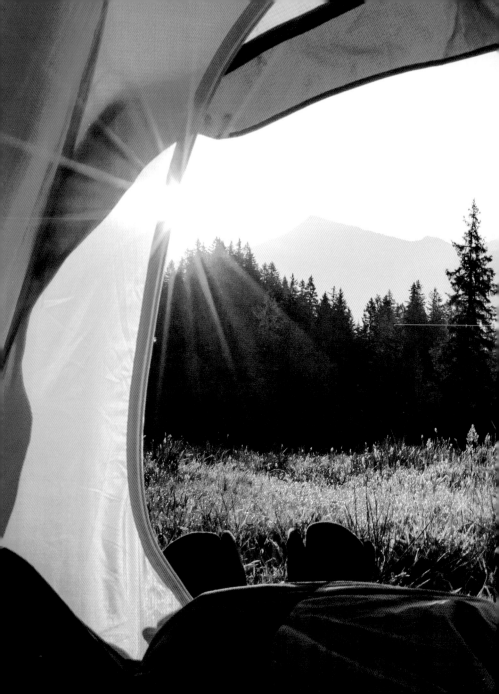

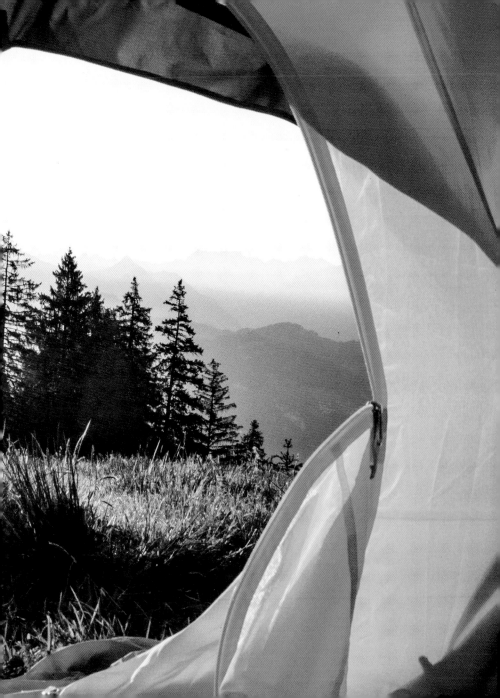

'To find the universal elements enough; to find the air and the water exhilarating; to be refreshed by a morning walk or an evening saunter. . . to be thrilled by the stars at night; to be elated over a bird's nest or a wildflower in spring — these are some of the rewards of the simple life.'

–John Burroughs

Place Fell, Lake District, England
54.5441° N, 2.9263° W

DUNCAN ANDISON

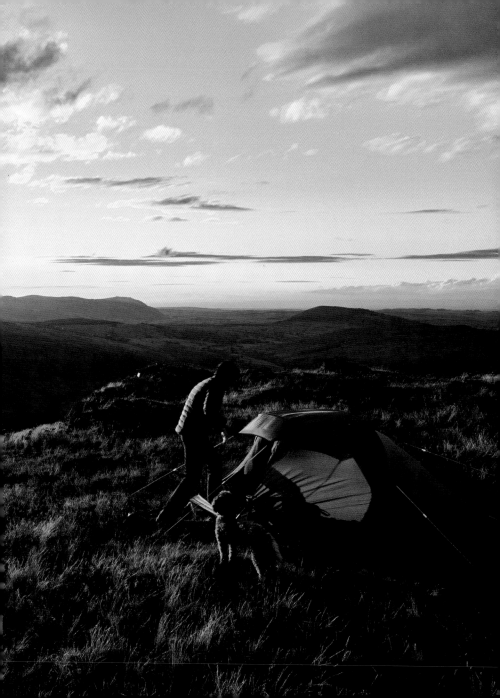

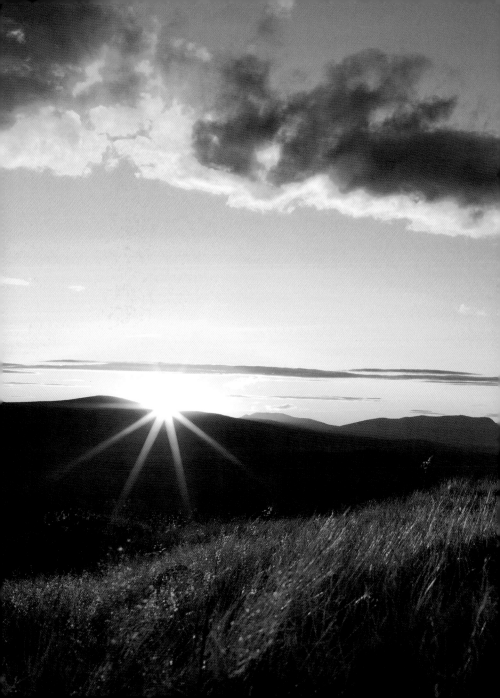

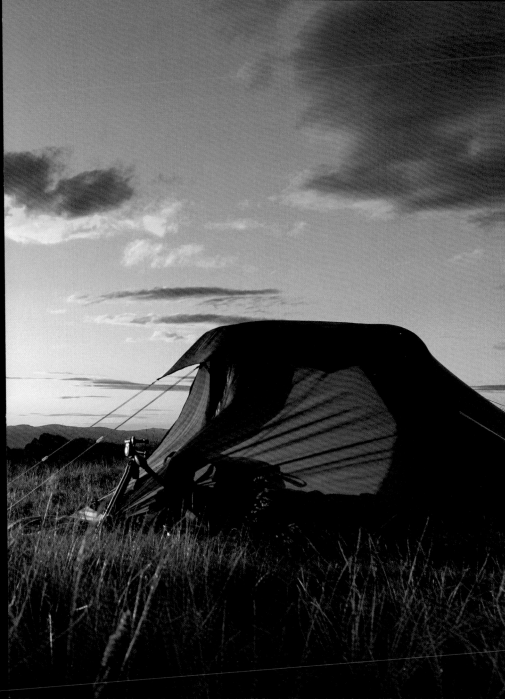

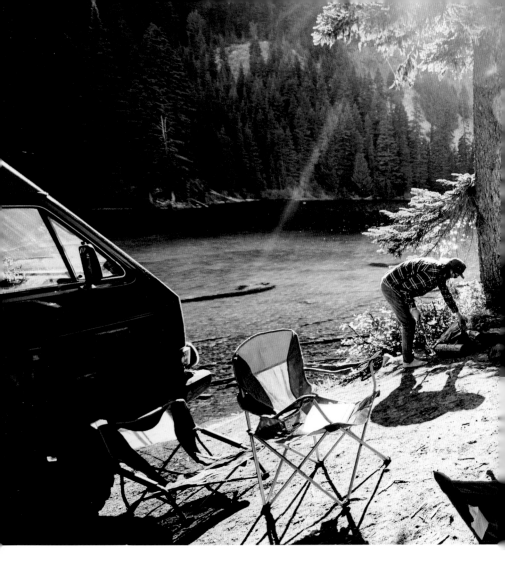

Mountain Lake, Washington, USA
48.6603° N, 122.8156° W

@BARWICK_PHOTO

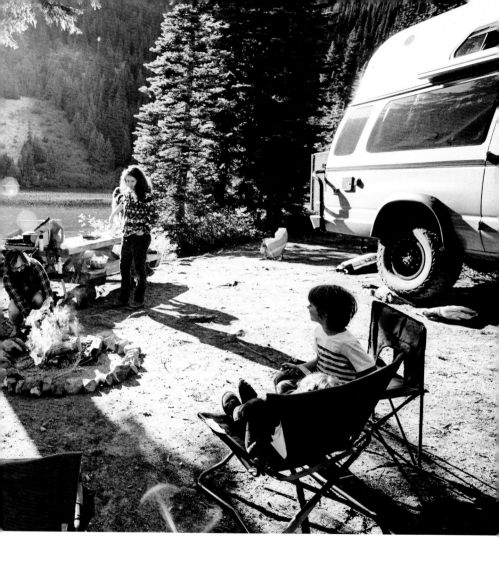

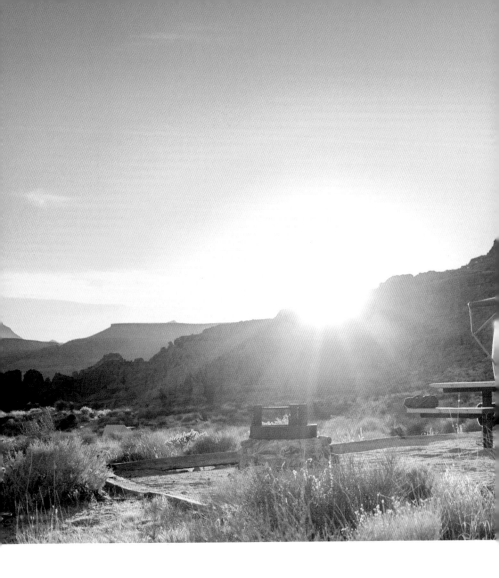

Mojave National Preserve, California, USA
35.1552° N, 115.4483° W

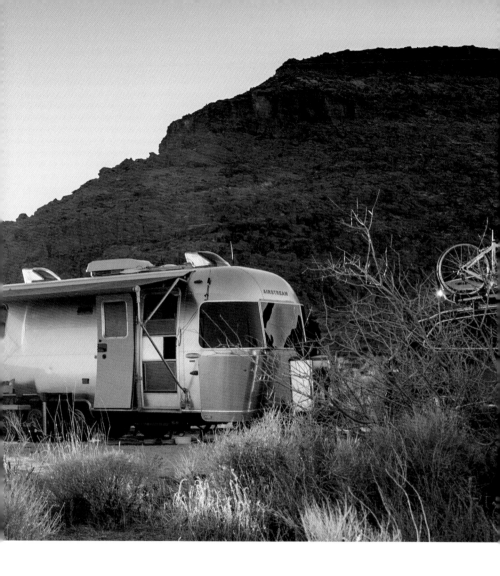

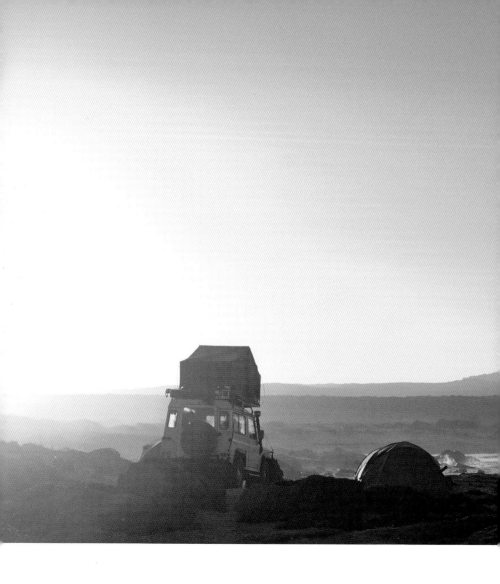

Cape Town, South Africa
33.9249° S, 18.4241° E

@JEFFBERGEN

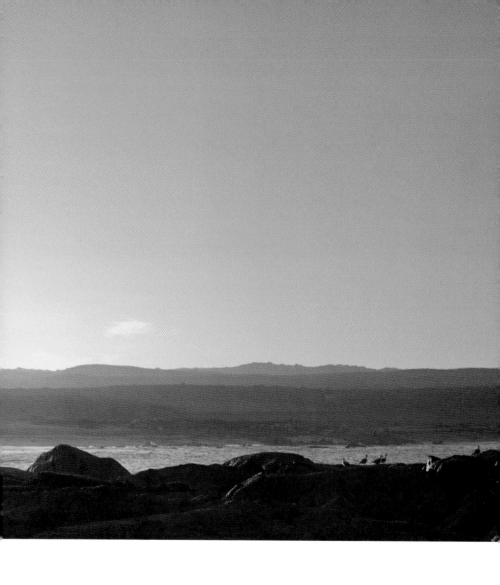

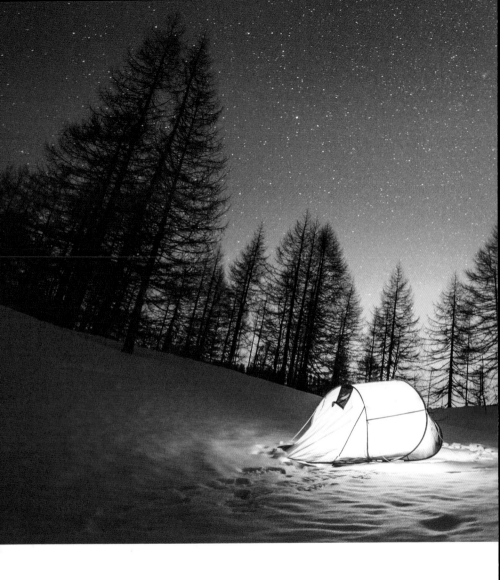

Veglia-Devero, Verbania, Italy
46.1400° N, 8.2725° E

@MARCOBOTTIGELLI

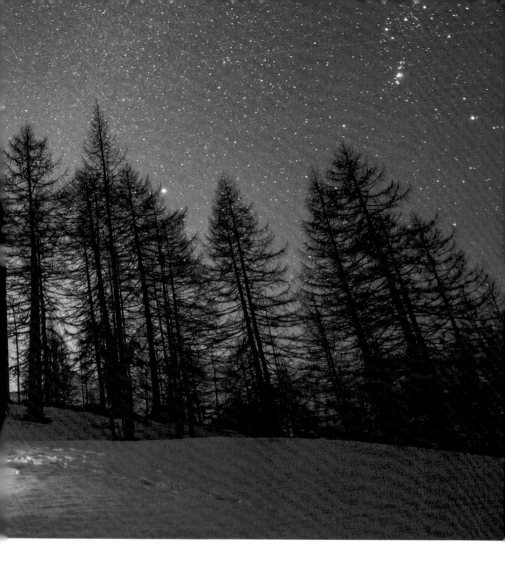

Cascata di Ferrera, Ferrera di Varese, Italy
45.9314° N, 8.7872° E

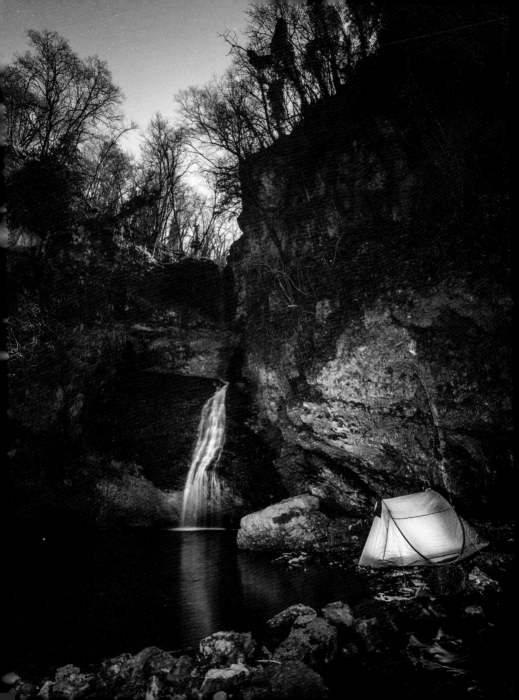

Yorkshire Dales, Bainbridge, England
54.3063° N, 2.1061° W

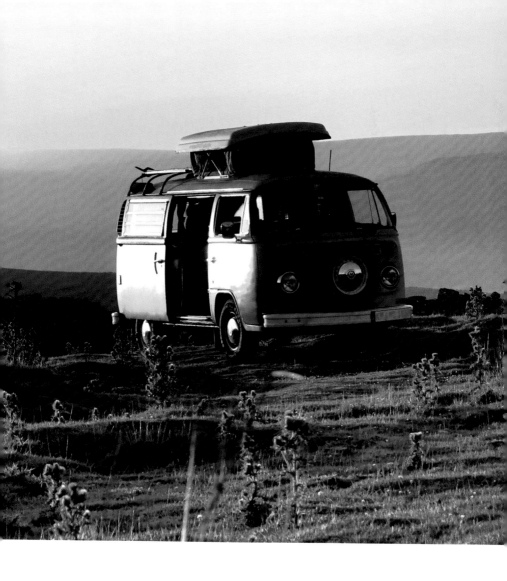

'Wilderness is
not a luxury but a
necessity of the
human spirit, and
as vital to our lives
as water and
good bread.'

–Edward Abbey

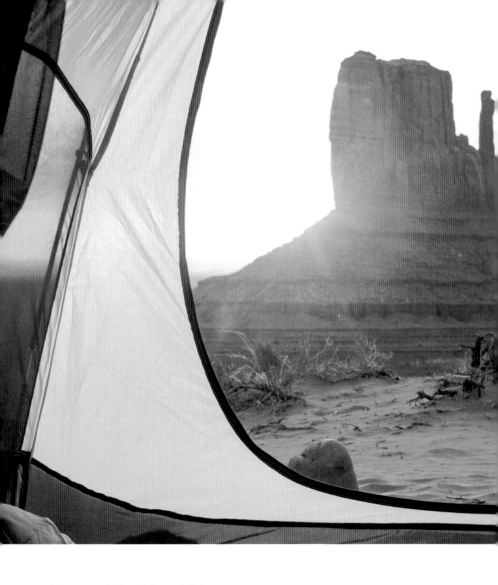

Monument Valley, Arizona, USA
36.9980° N, 110.0985° W

@1885ATELIER

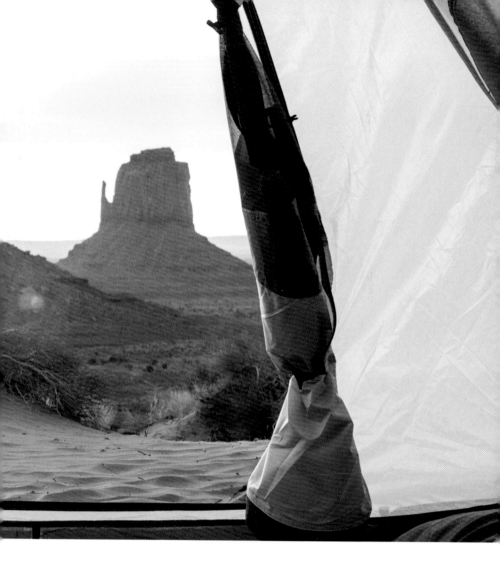

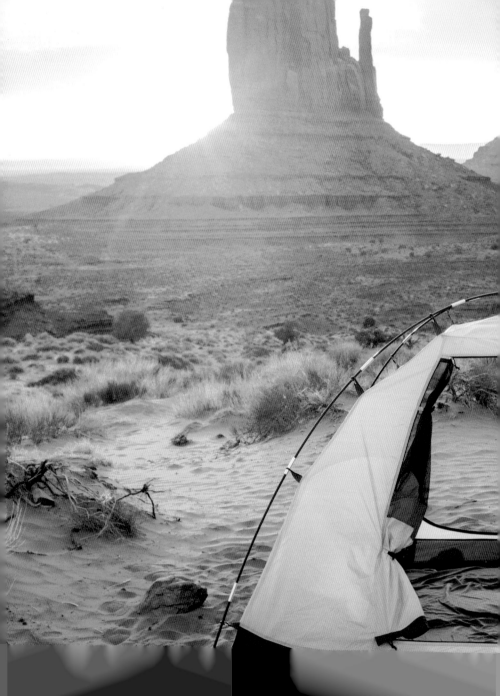

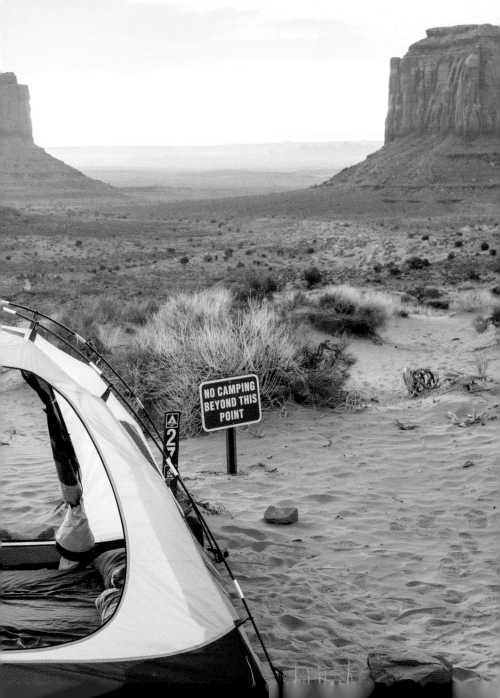

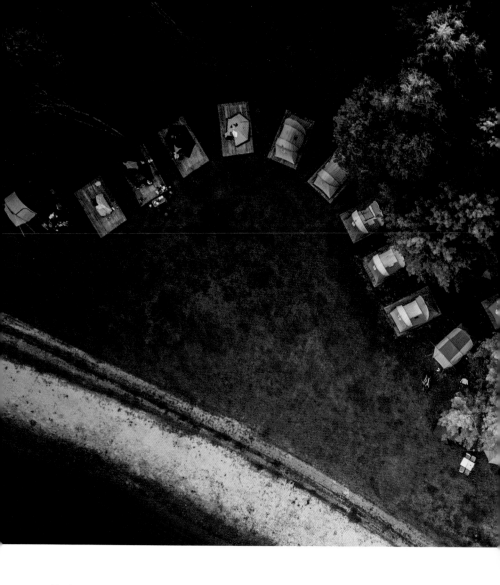

Zavidovo, Tver Oblast, Russia
57.0022° N, 33.9853° E

@EVGENY_KUKLEV_IMAGES

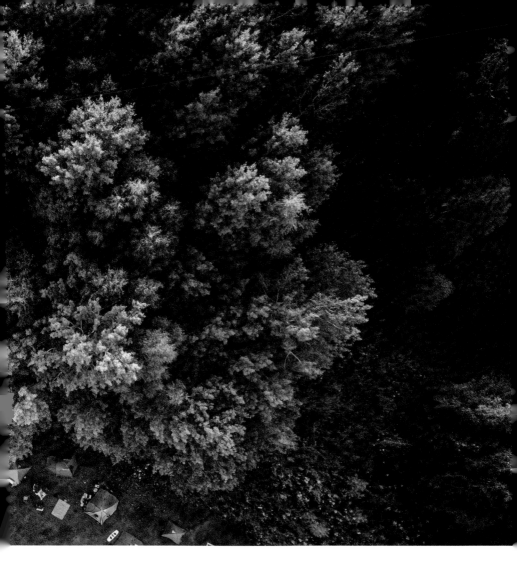

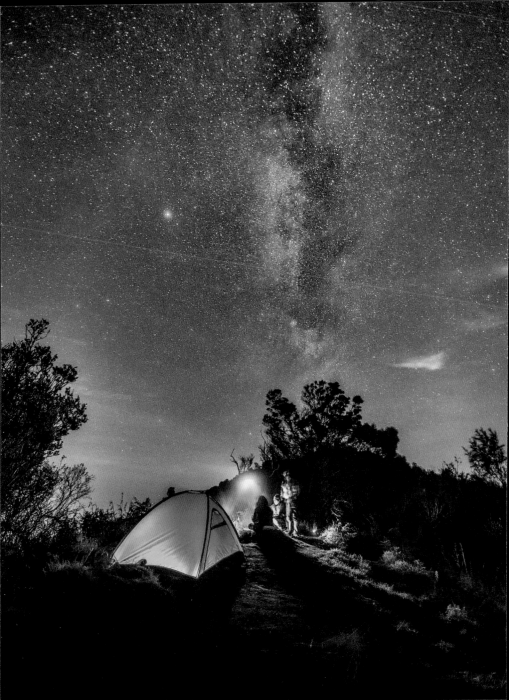

Mount Bromo, East Java, Indonesia
7.9425° S, 112.9530° E

@SUNSHINE_INLOVE

Banff National Park, Alberta, Canada
51.4968° N, 115.9281° W

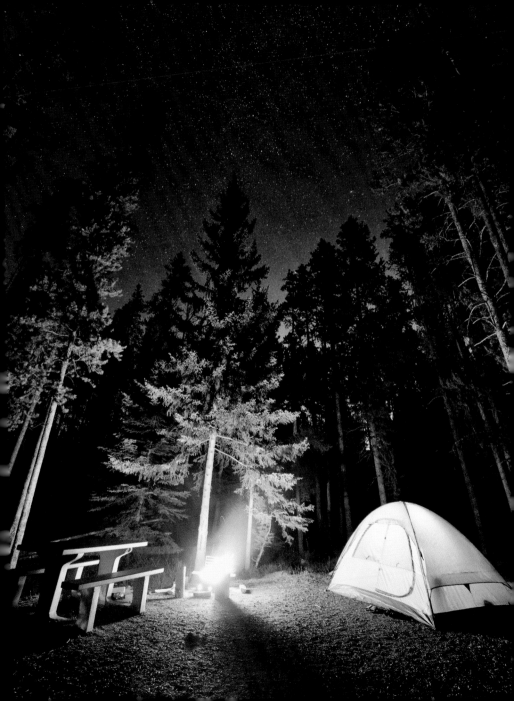

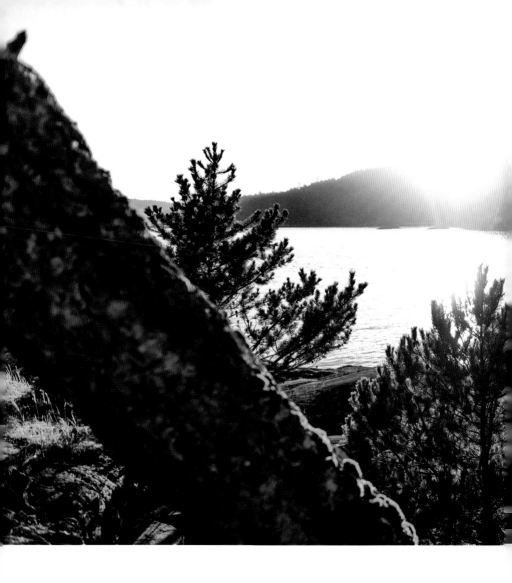

Telegraph Cove, British Columbia, Canada
50.5492° N, 126.8323° W

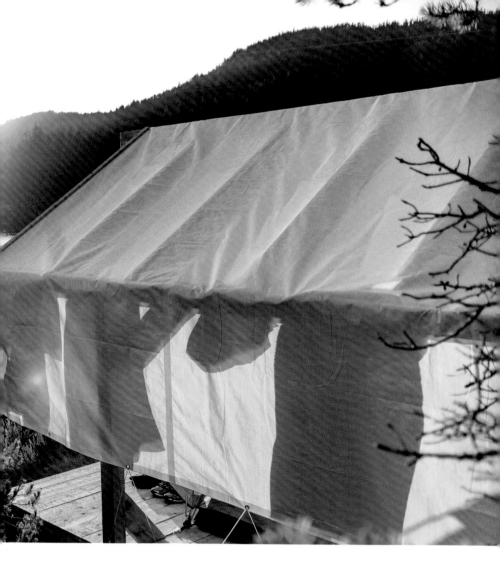

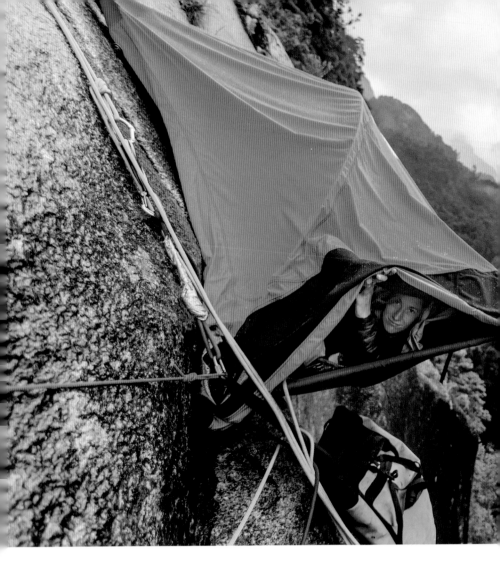

Cochamó, Los Lagos, Chile
41.4924° S, 72.3080° W

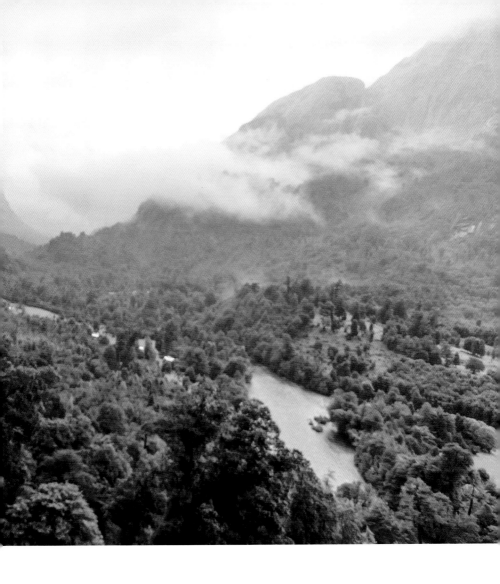

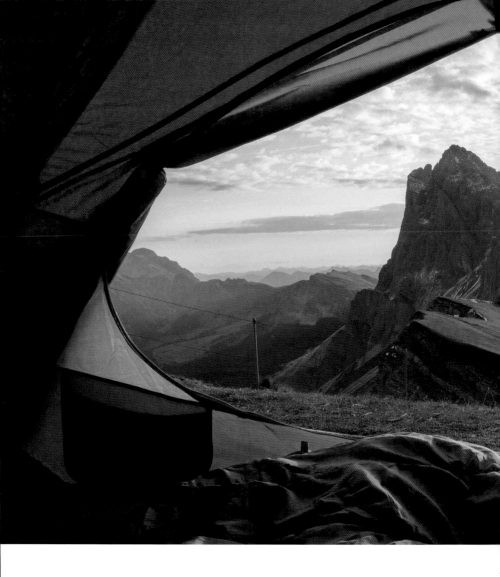

Dolomites, Trentino-South Tyrol, Italy
46.4102° N, 11.8440° E

@EVGENIYBILETSKIY

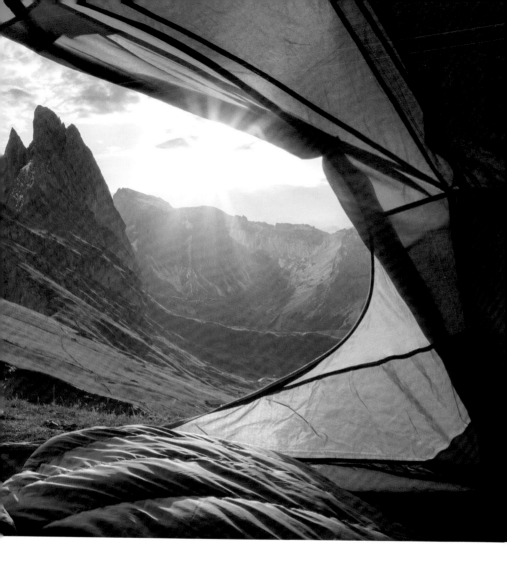

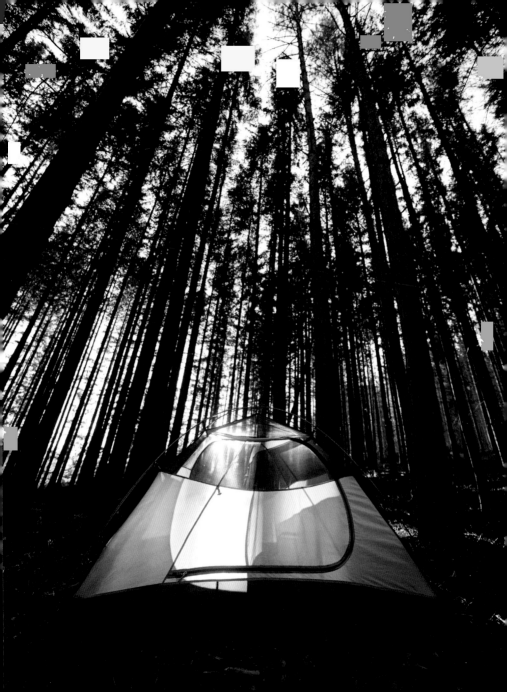

Ivano-Frankivsk Oblast, Carpathian Mountains, Ukraine
48.9226° N, 24.7111° E

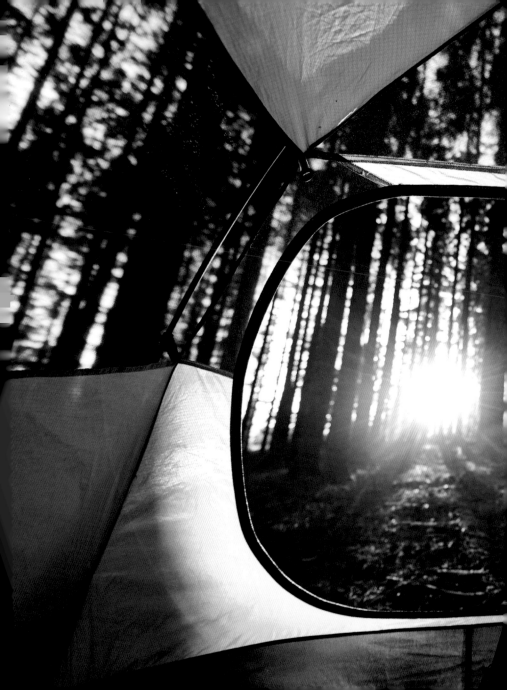

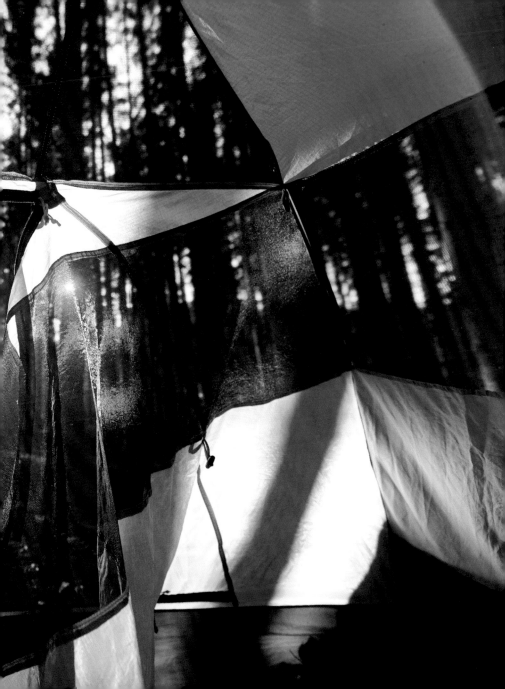

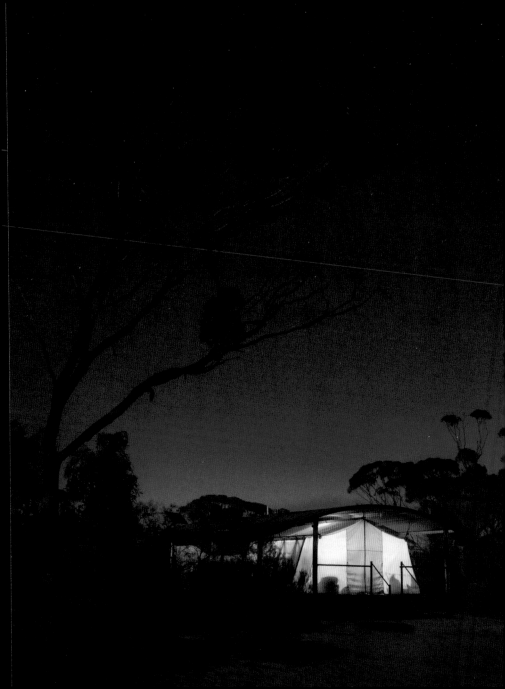

Gawler Ranges, South Australia, Australia
32.5742° S, 135.5253° E

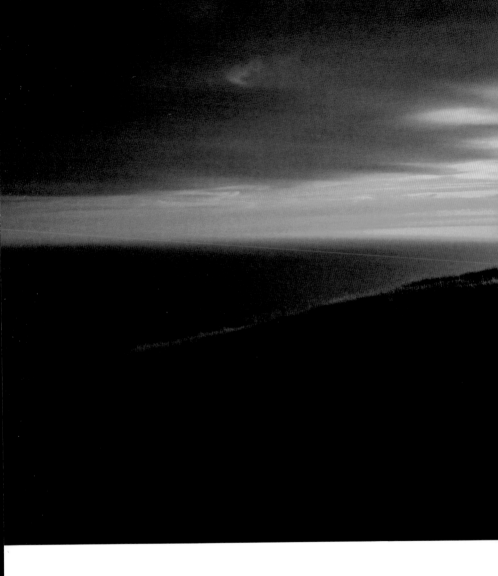

Big Sur, California, USA
36.2704° N, 121.8081° W

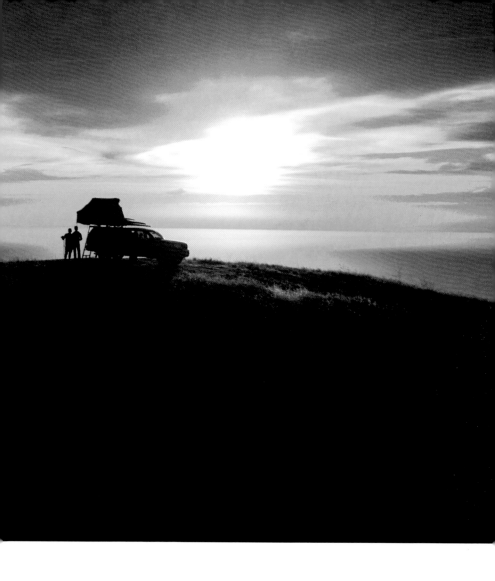

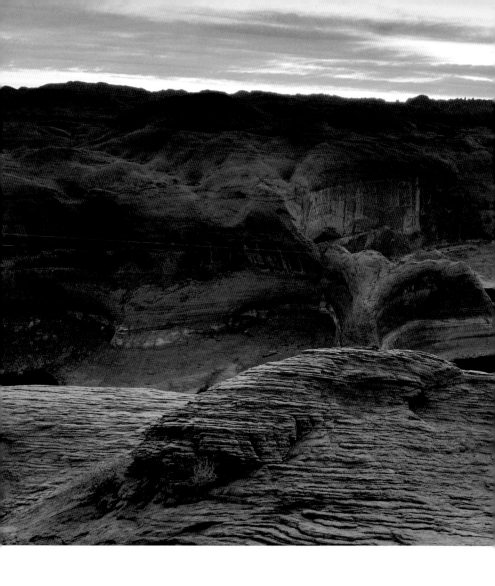

Lake Powell, Utah, USA
37.0683° N, 111.2433° W

LIJUAN GUO

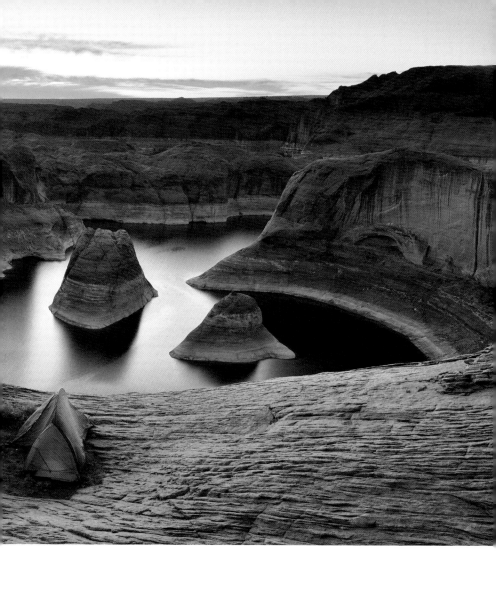

Mt. Baker–Snoqualmie National Forest, Washington, USA
47.7659° N, 121.3778° W

LIJUAN GUO

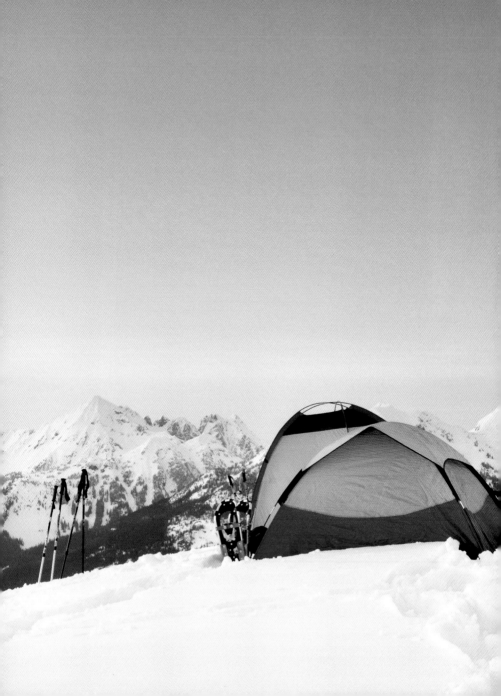

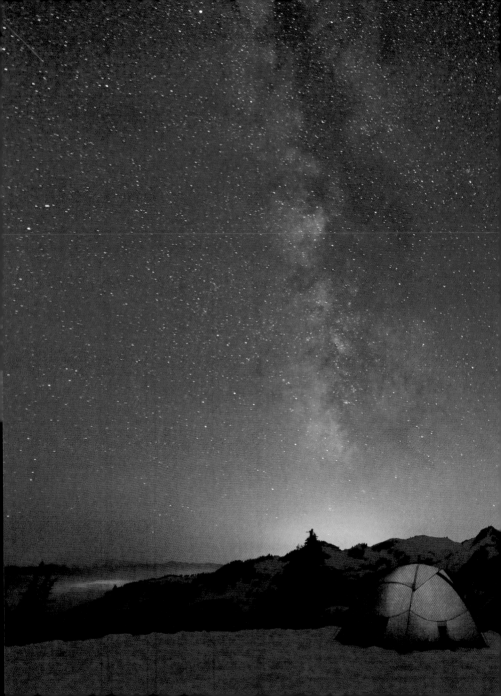

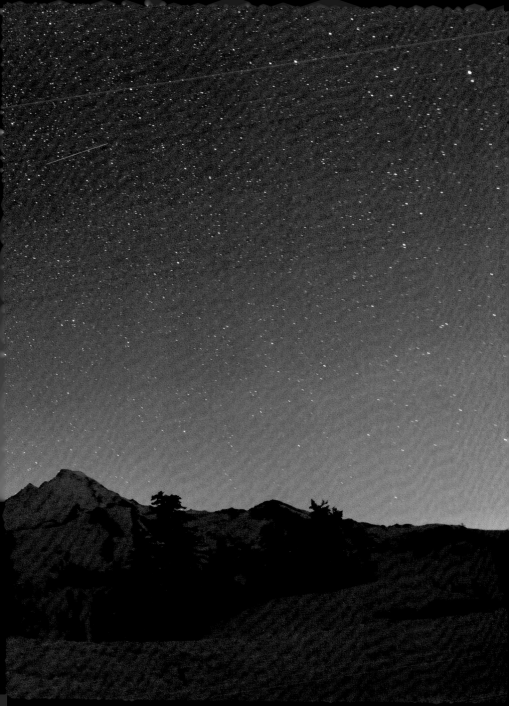

'Walk away quietly in any direction and taste the freedom of the mountaineer. Camp out among the grasses and gentians of glacial meadows, in craggy garden nooks full of nature's darlings. Climb the mountains and get their good tidings, Nature's peace will flow into you as sunshine flows into trees.'

–John Muir

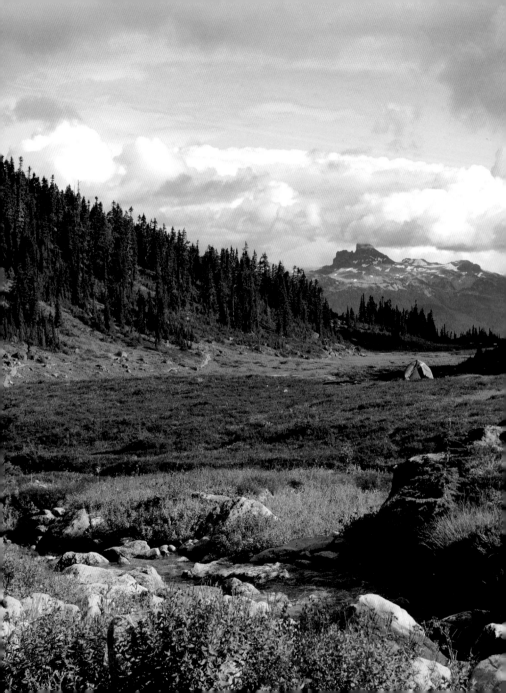

Brandywine Meadows, British Columbia, Canada
50.0783° N, 123.1863° W

LIJUAN GUO

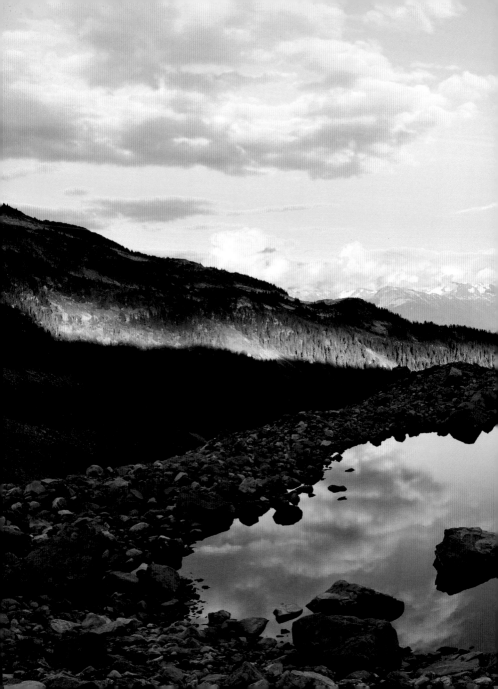

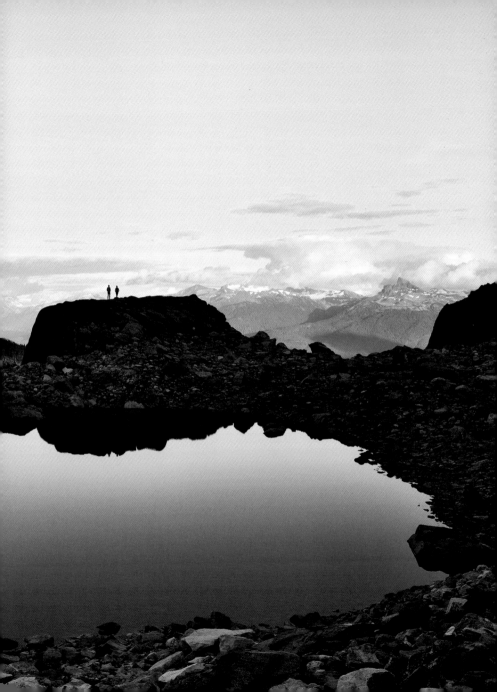

Joshua Tree National Park, California, USA
33.8734° N, 115.9010° W

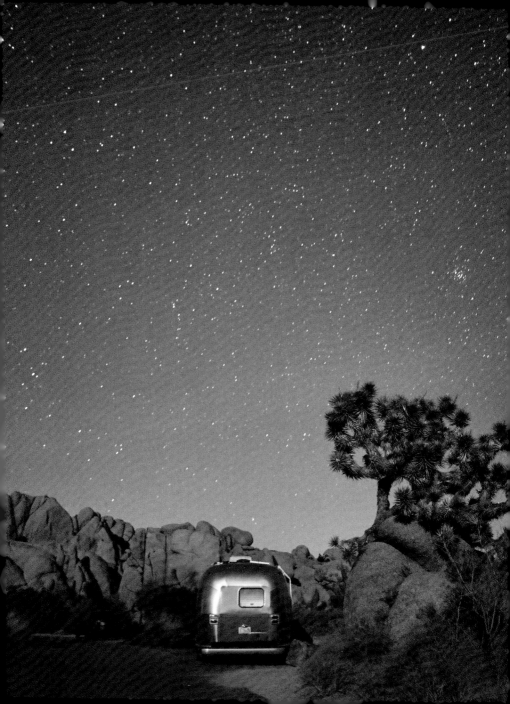

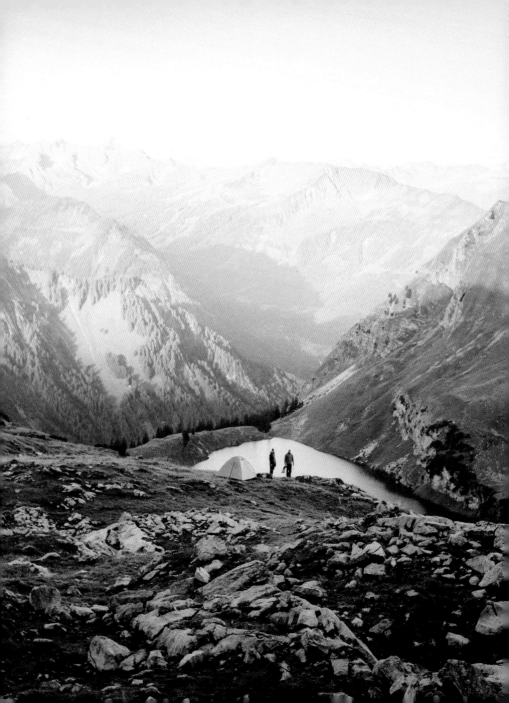

Oberstdorf, Bavaria, Germany
47.4099° N, 10.2797° E

@BOKEHM0N

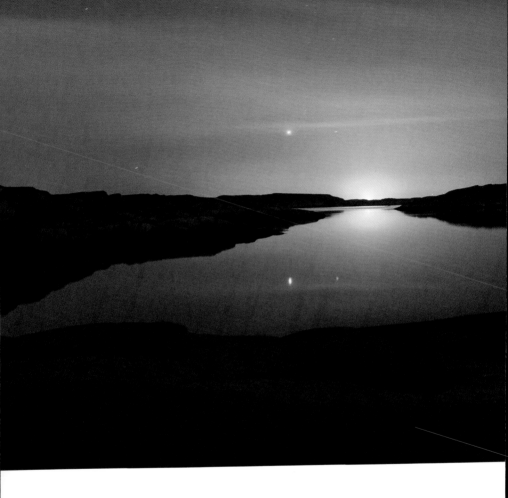

Fjällbacka, Västra Götaland, Sweden
58.5998° N, 11.2882° E

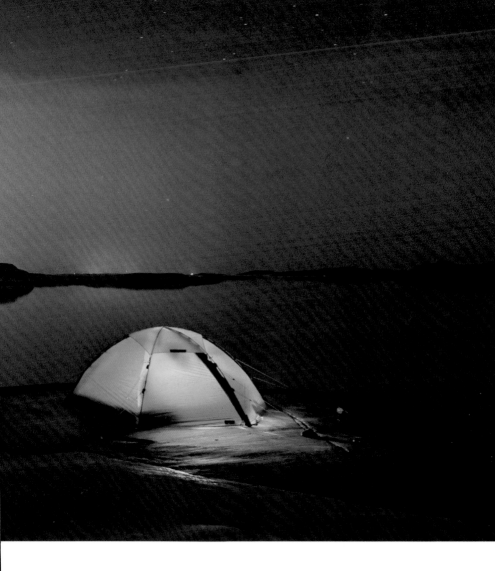

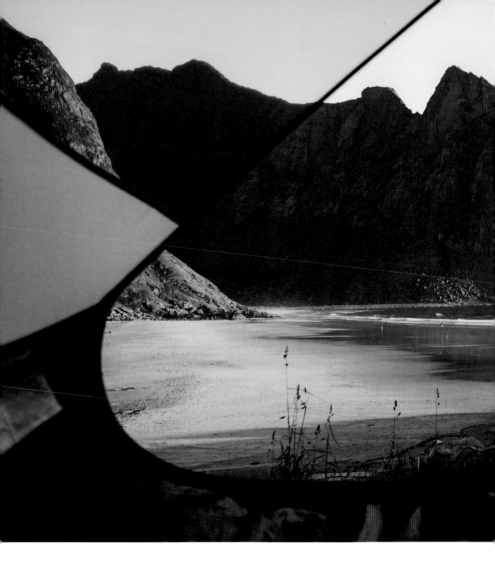

Kvalvika Beach, Lofoten Islands, Norway
68.4711° N, 13.8636° E

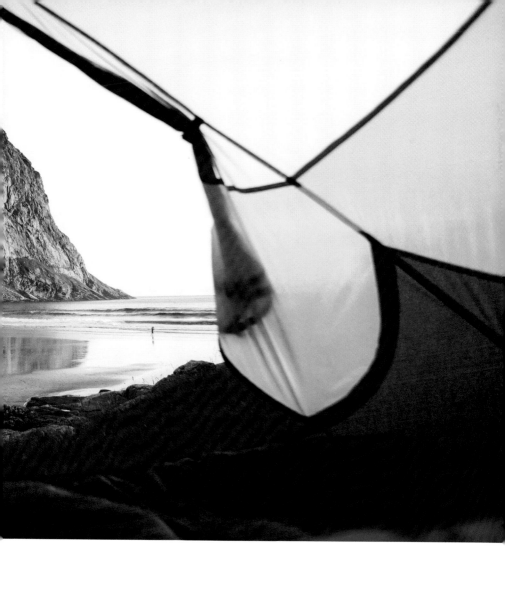

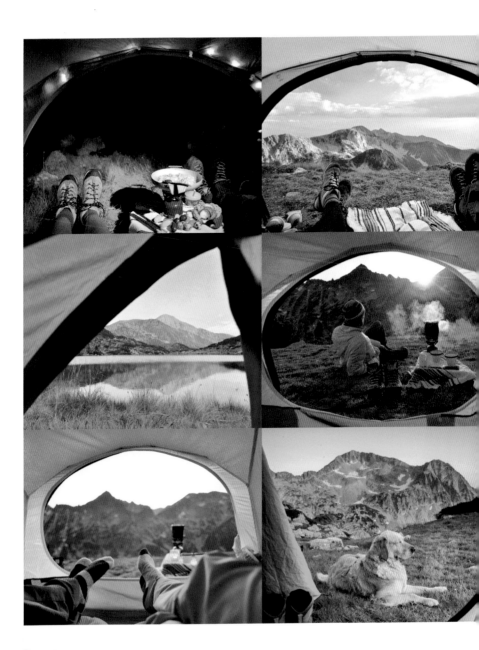

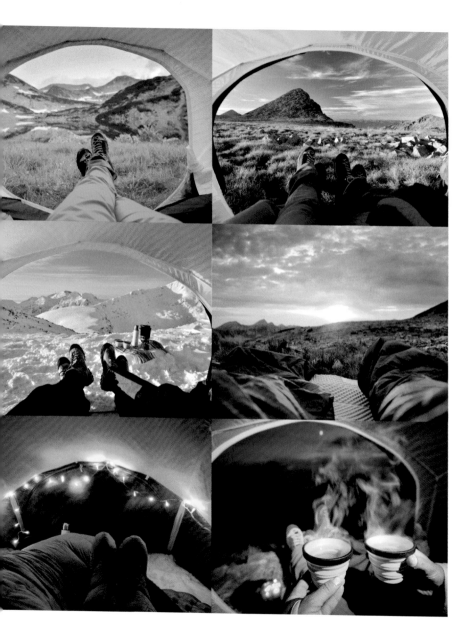

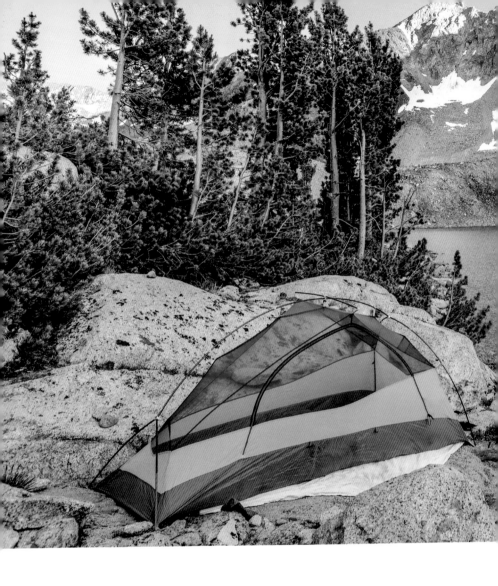

Lake Marjorie, California, USA
36.9444°N, 118.4310°W

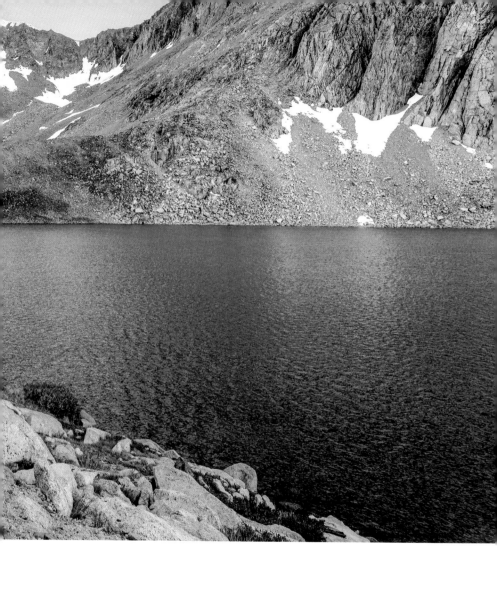

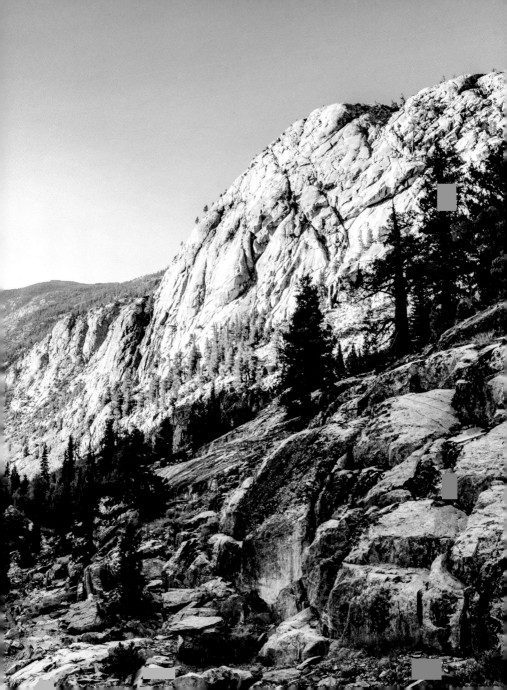

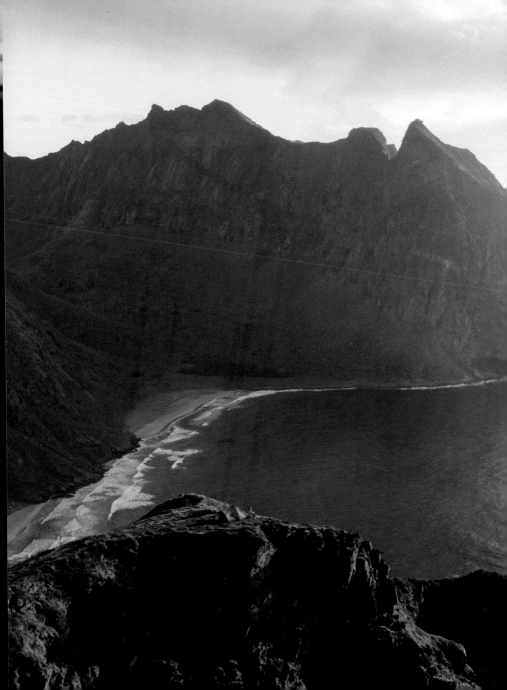

Kvalvika Beach, Lofoten Islands, Norway
68.4711° N, 13.8636° E

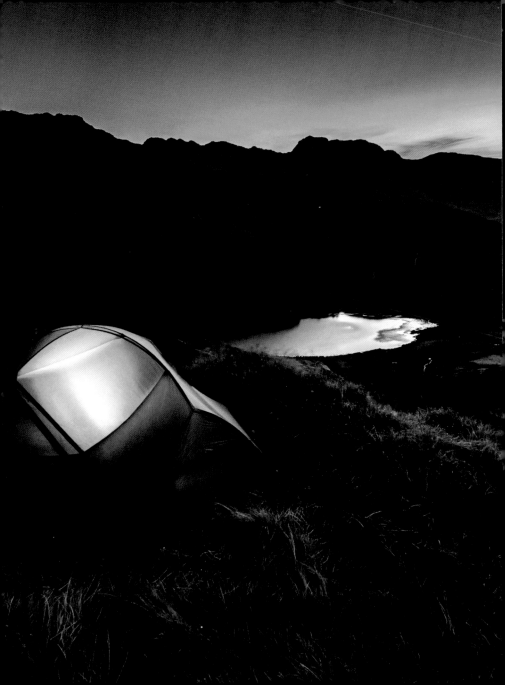

Great Langdale, Lake District, England
54.4517° N, 3.0776° W

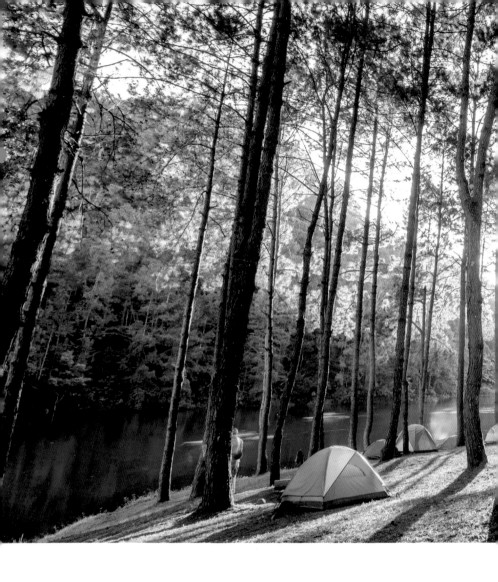

Pang Oung, Mae Hong Son, Thailand
19.4984° N, 97.9092° E

@MUMEMORIES

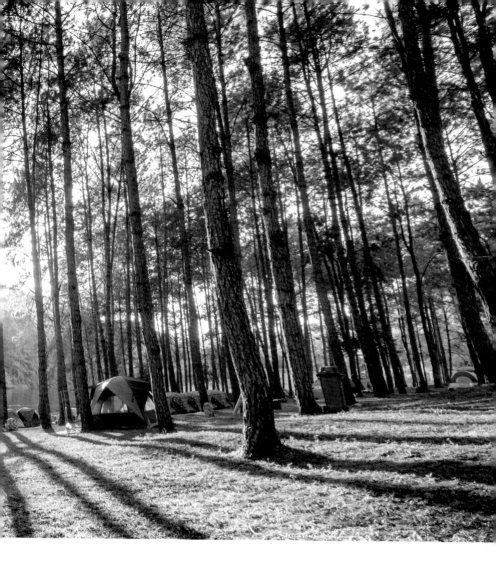

Svydovets, Transcarpathia, Ukraine
48.2772° N, 24.1522° E

KAPULYA

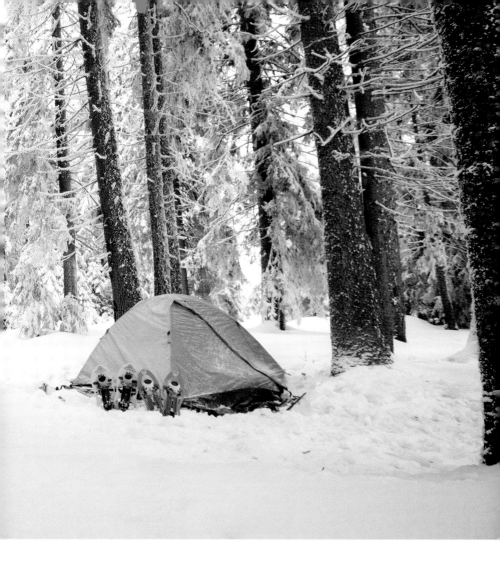

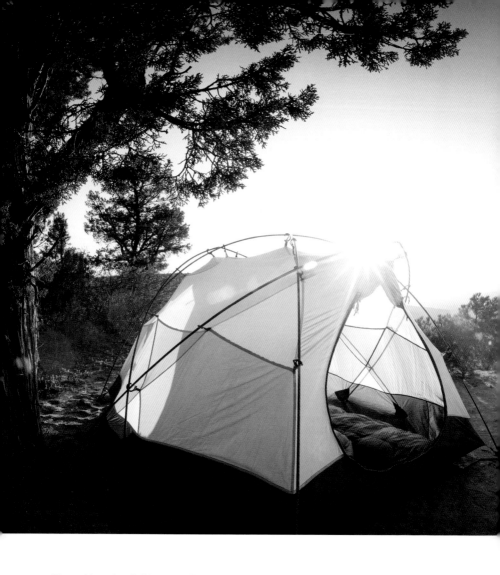

Sierra Nevada, California, USA
38.2692° N, 119.5742° W

@JUSTINLEWISONTHEROAD

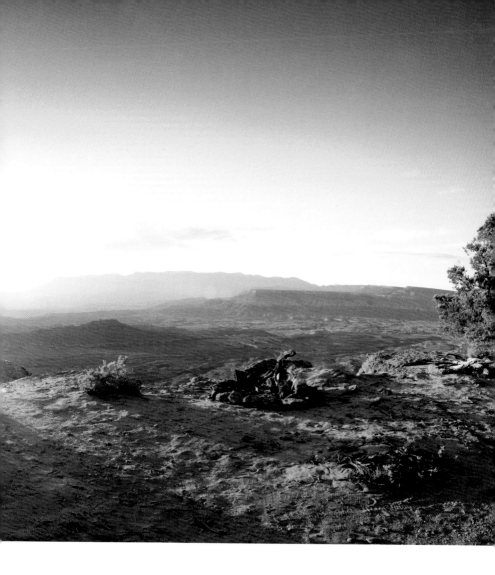

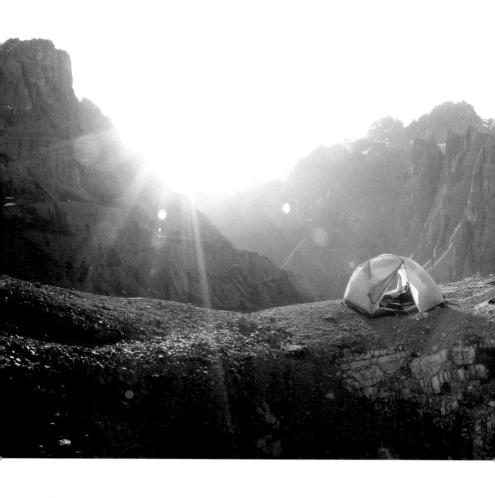

Dolomites, Trentino-South Tyrol, Italy
46.4102° N, 11.8440° E

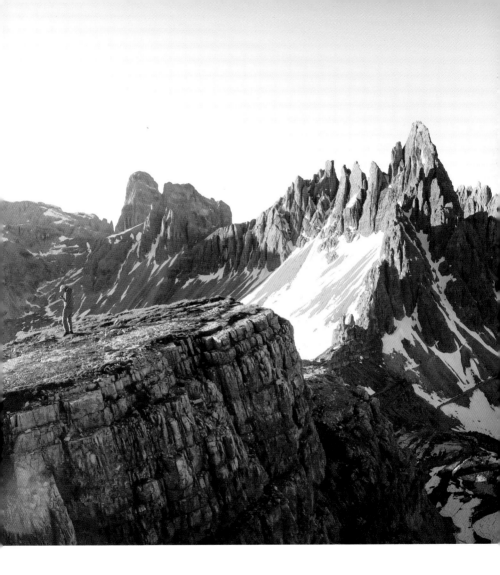

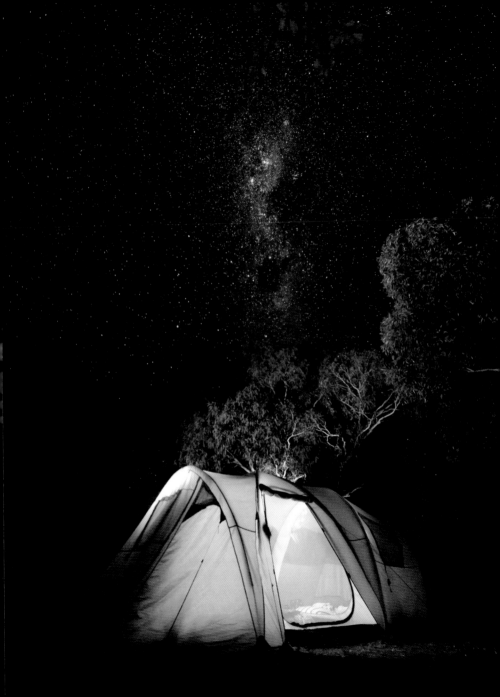

Grampians National Park, Victoria, Australia
37.2109° S, 142.3980° E

@ONPATROLPHOTO

'The outside is
the only place we
can truly be inside
the world.'

–Daniel J. Rice

Hatta, Dubai, United Arab Emirates
24.8062° N, 56.1254° E

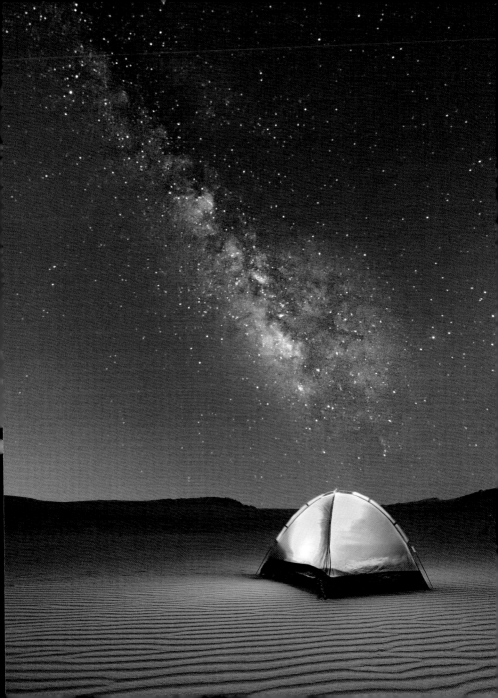

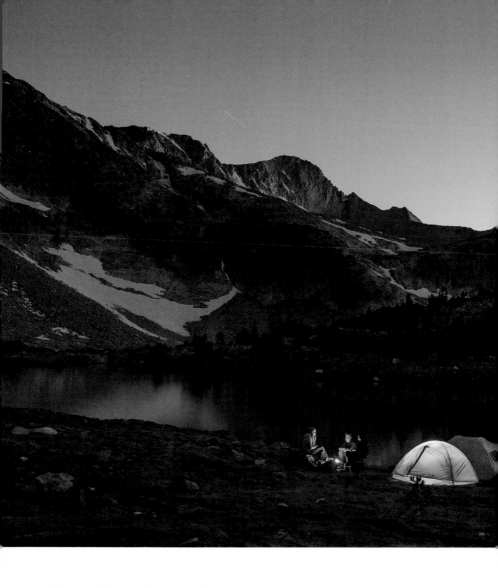

Mammoth Lakes, California, USA
37.6485° N, 118.9721° W

@SCOTTMARKEWITZ

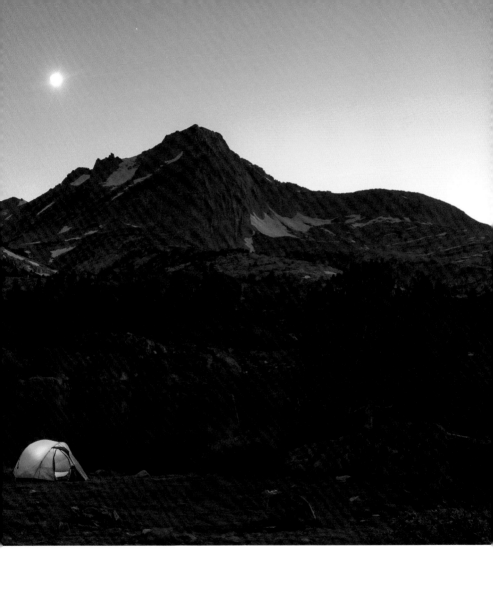

Bucegi Mountains, Brașov, Romania
45.3982° N, 25.4938° E

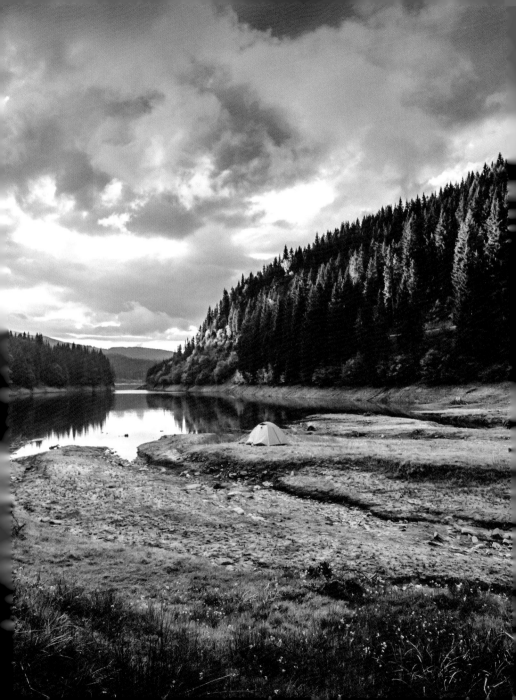

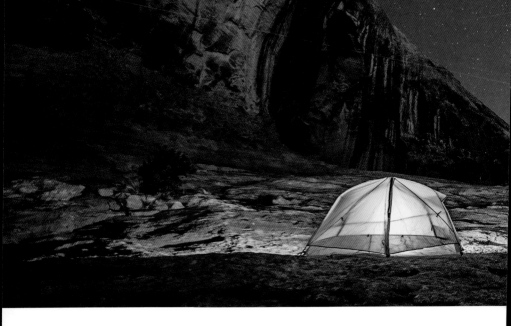

Moab, Utah, USA
38.5733° N, 109.5498° W

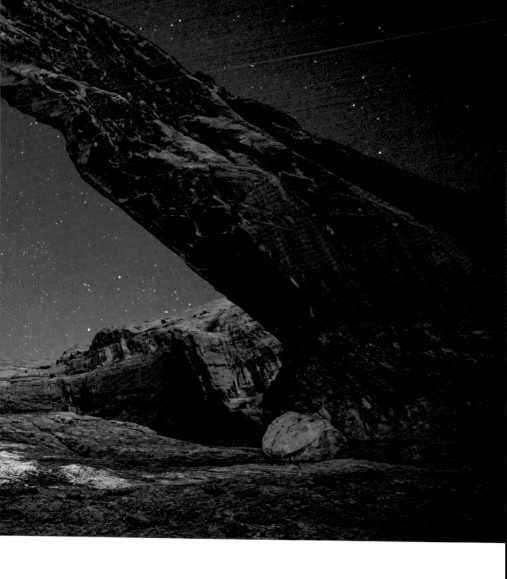

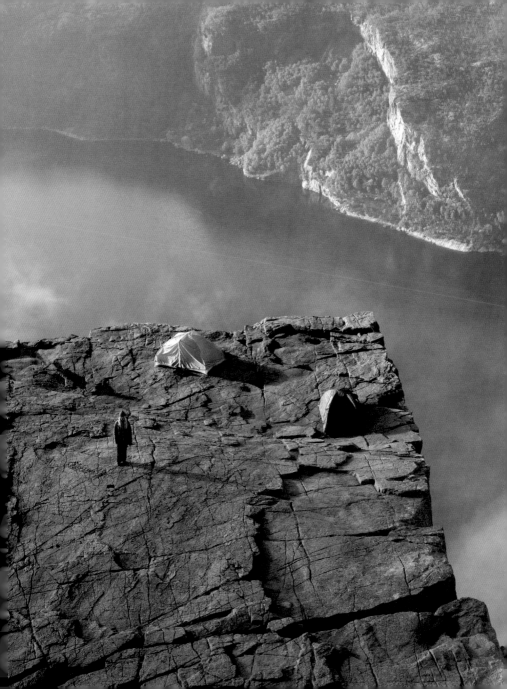

Preikestolen, Rogaland, Norway
58.9864° N, 6.1904° E

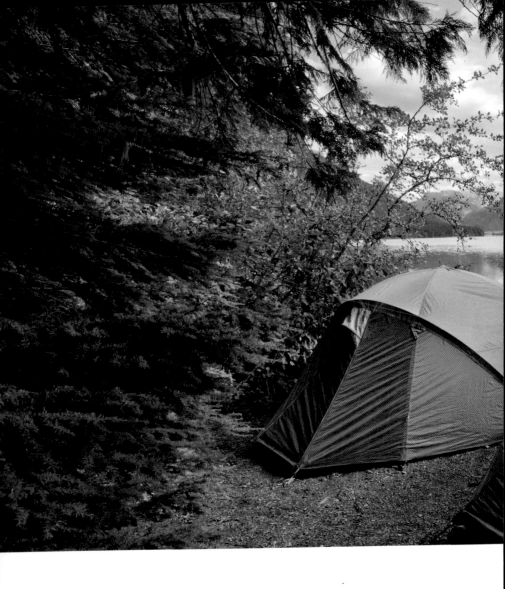

Whistler, British Columbia, Canada
50.1163° N, 122.9574° W

LEON U

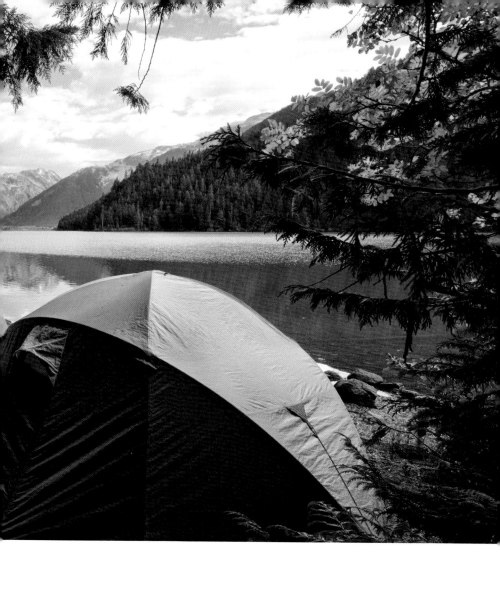

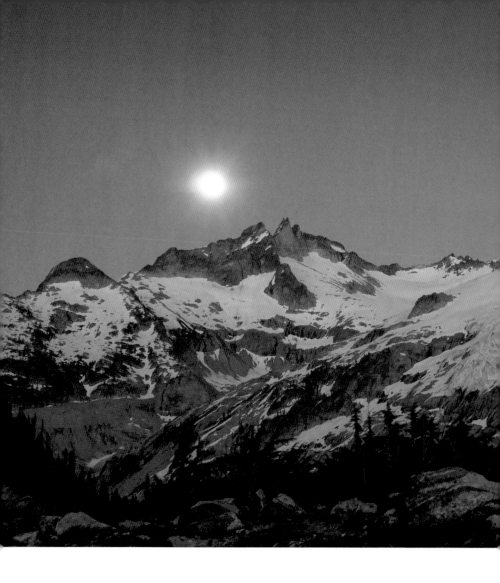

White Rock Lakes, Washington, USA
48.3407° N, 121.0540° W

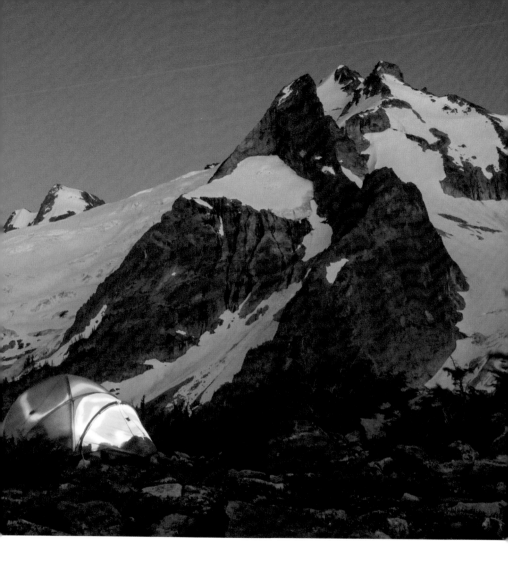

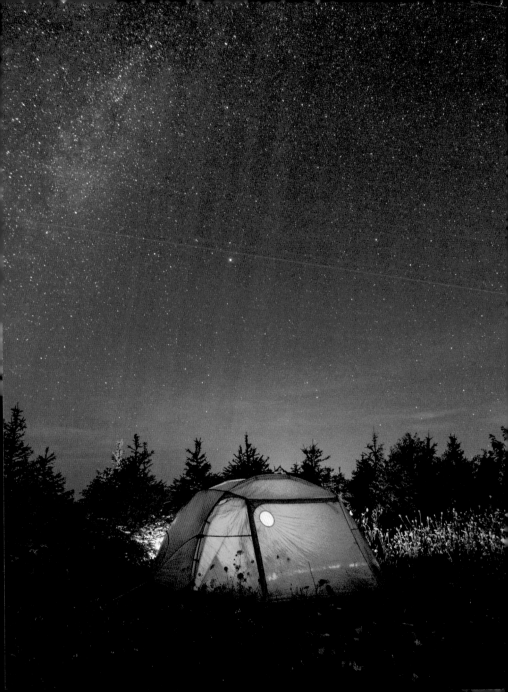

Coudersport, Pennsylvania, USA
41.7748° N, 78.0206° W

MINT IMAGES

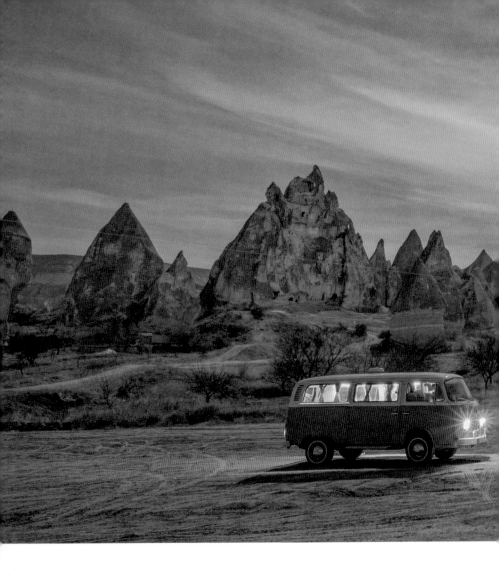

Göreme, Cappadocia, Turkey
38.6431° N, 34.8289° E

@MGSTUDYO

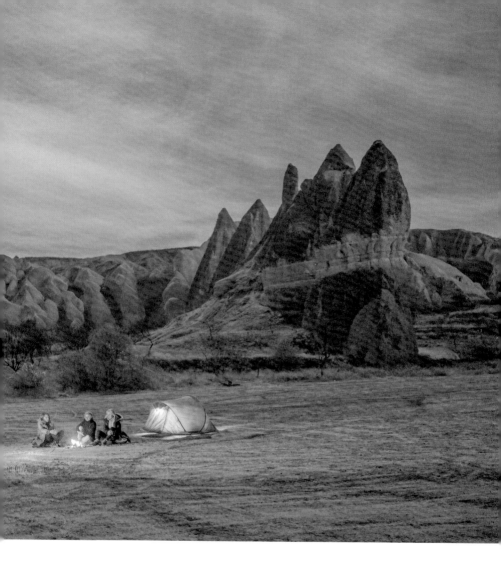

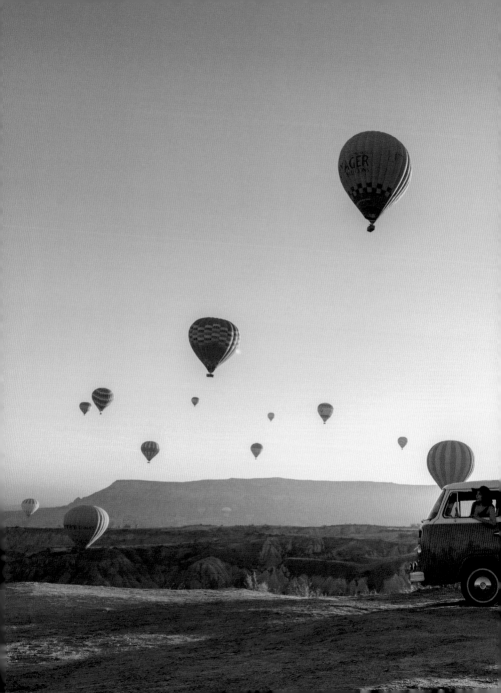

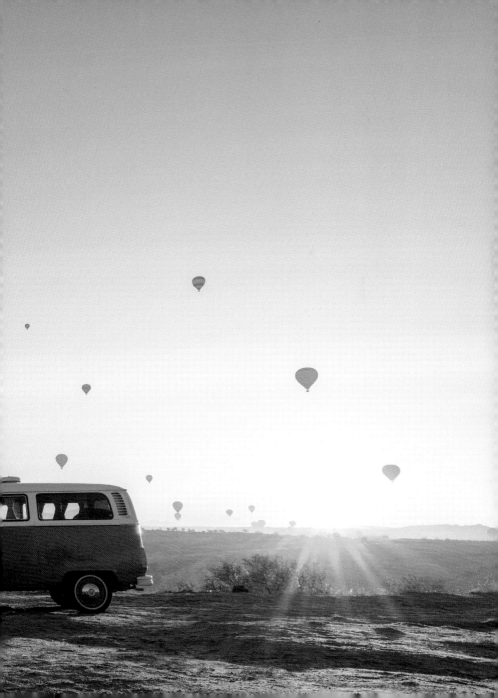

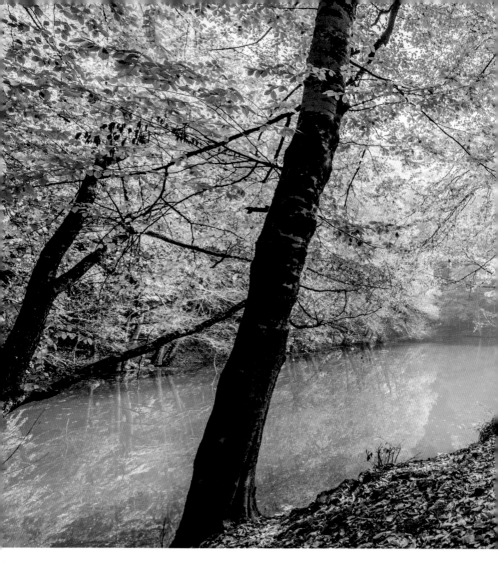

Yedigöller National Park, Bolu, Turkey
40.9415° N, 31.7472° E

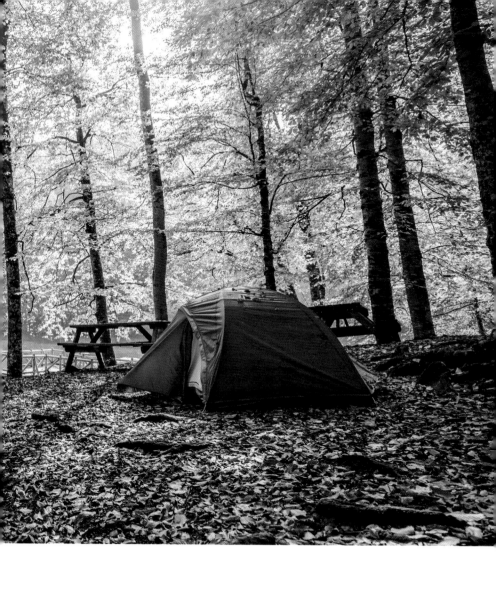

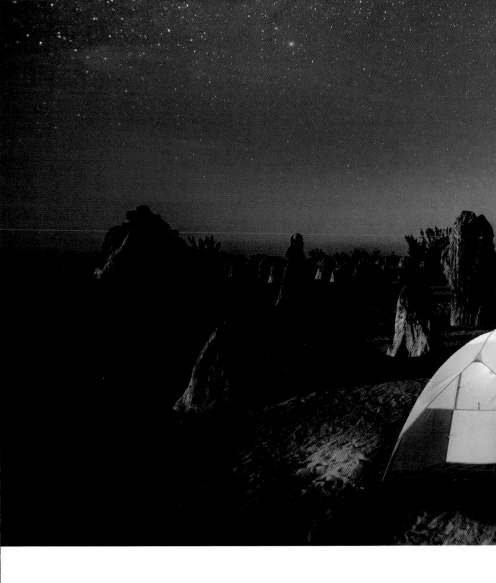

Pinnacles Desert, Western Australia, Australia
30.5911° S, 115.1602° E

NEOPHOTO

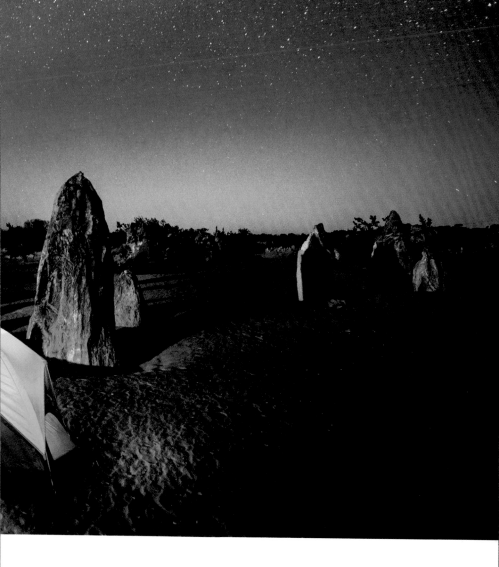

The Storr, Skye, Scotland
57.5071° N, 6.1831° W

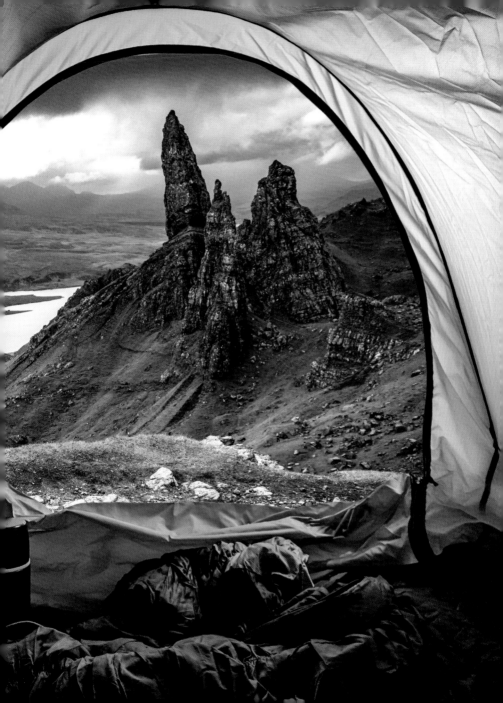

Forest Lake, Utah, USA
40.5121° N, 111.5852° W

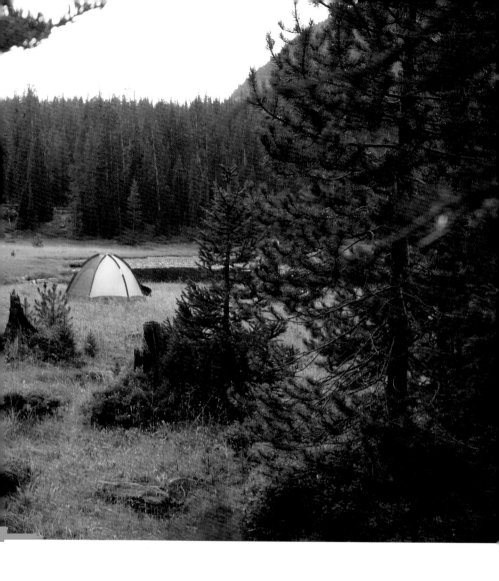

Lake Baikal, Siberia, Russia
53.5587° N, 108.1650° E

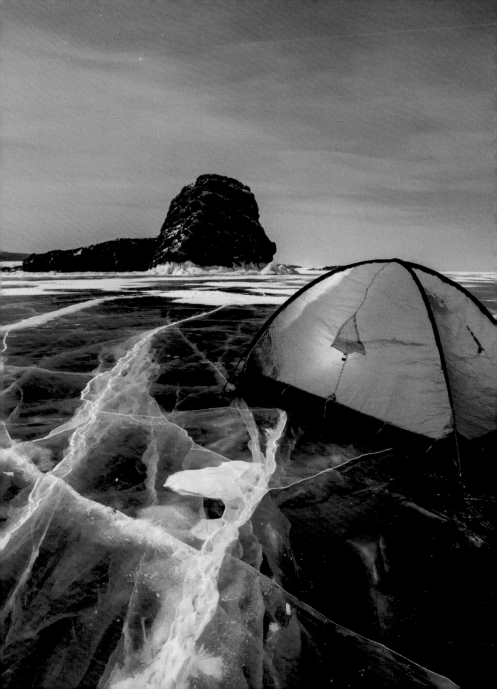

'I just want to
live in a world of
mountains, coffee,
campfires, cabins,
and golden trees,
and run around
with a camera and
notebook, learning
the inner workings
of everything real.'

–Victoria Erickson

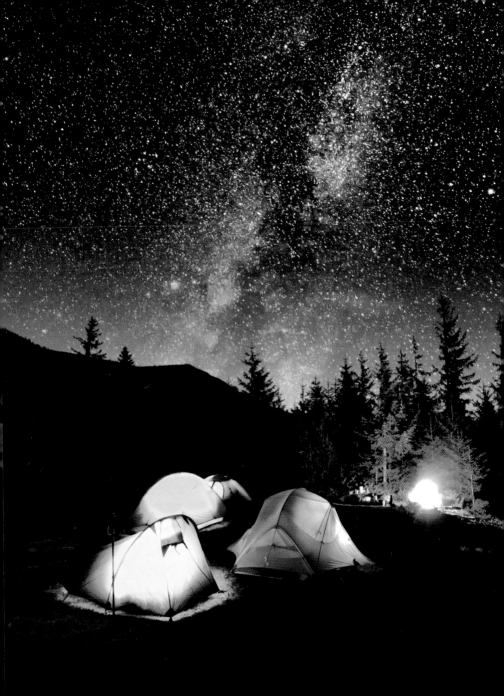

Vukhaty Kamen, Carpathian Mountains, Ukraine
47.2390° N, 25.5909° E

@ANTON_PETRUS

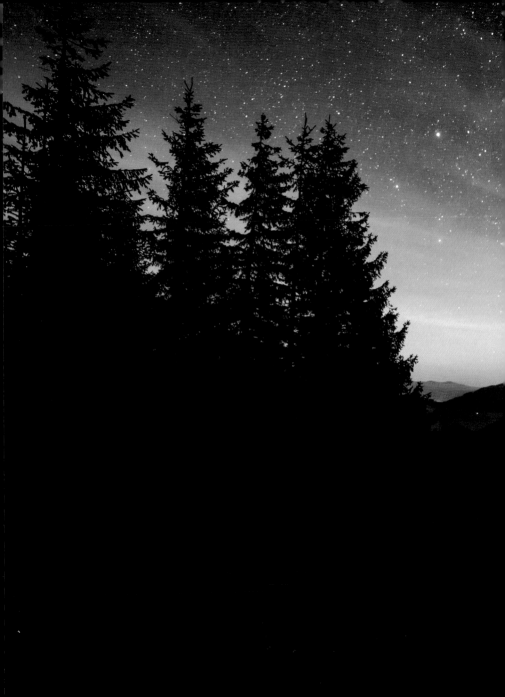

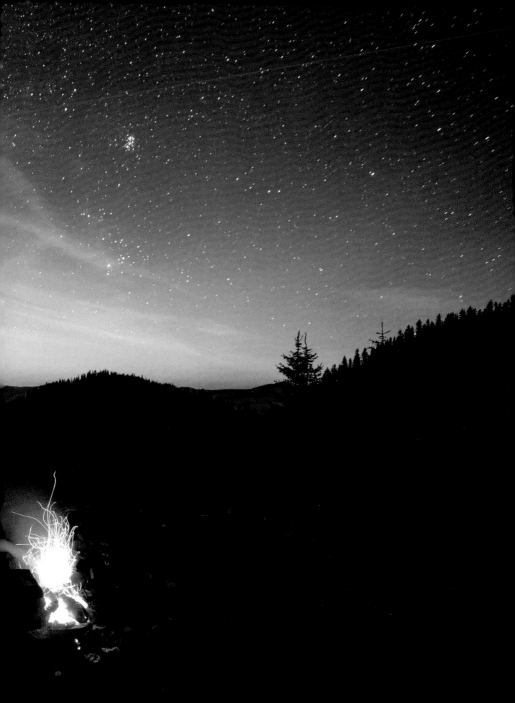

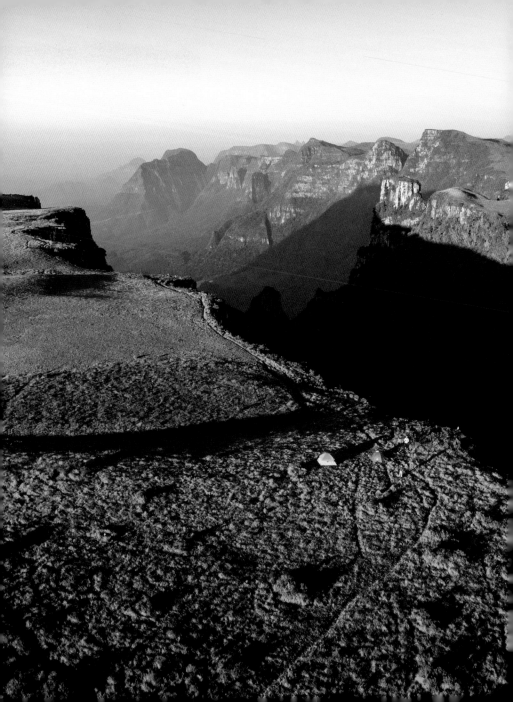

Cânion do Espraiado, Grão Pará, Brazil
28.0024° S, 49.3368° W

@LUCIANO_QUEIROZ

Lake Pukaki, Canterbury, New Zealand
44.0697° S, 170.1652° E

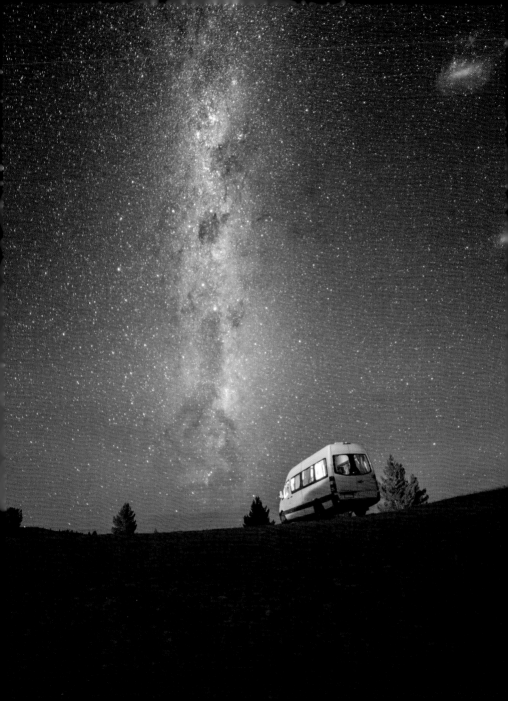

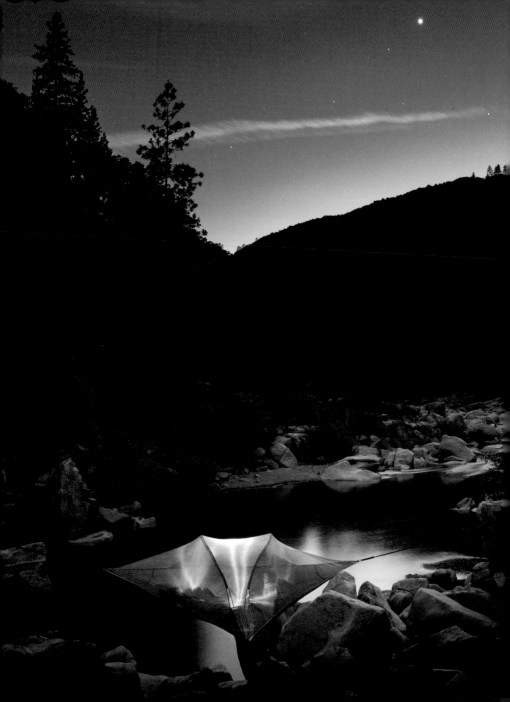

Nevada City, California, USA
39.2616° N, 121.0161° W

Taksin Maharat, Tak, Thailand
16.7786° N, 98.9286° E

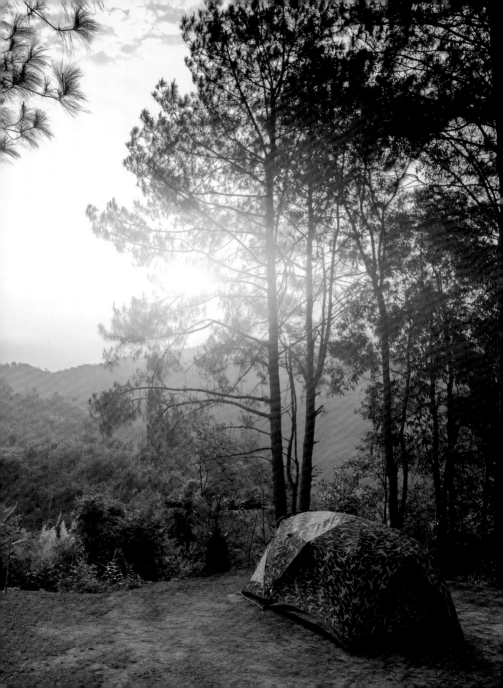

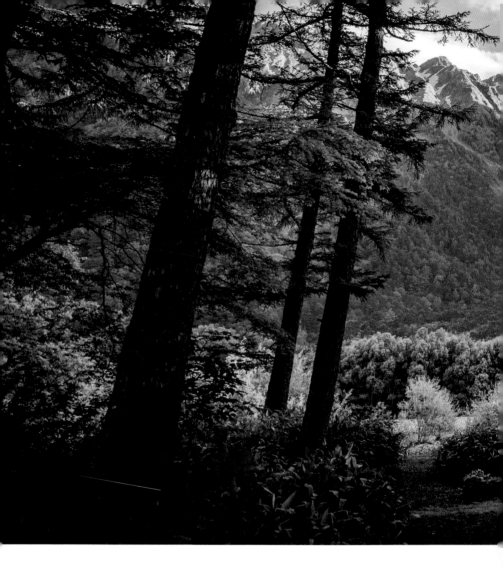

Kamikōchi National Park, Matsumoto, Japan
36.2892° N, 137.6481° E

@SPYARM

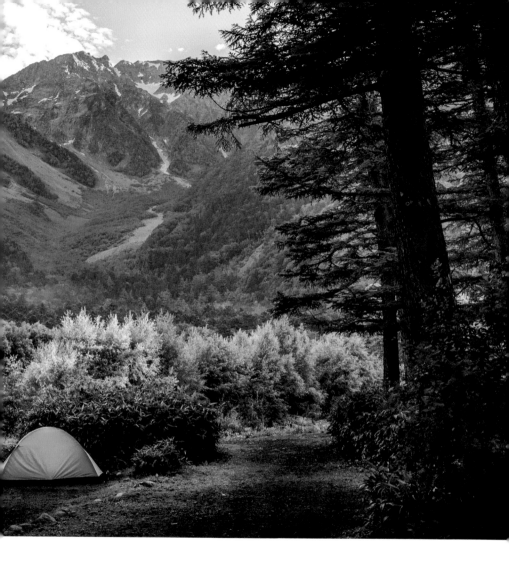

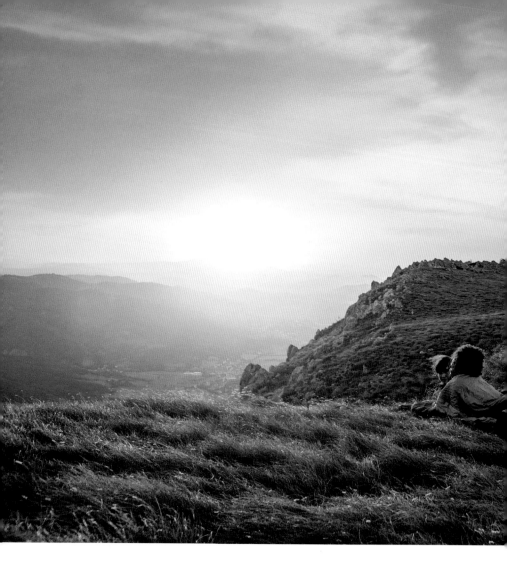

Nanos, Slovenia
45.8256° N, 13.9900° E

SANJERI

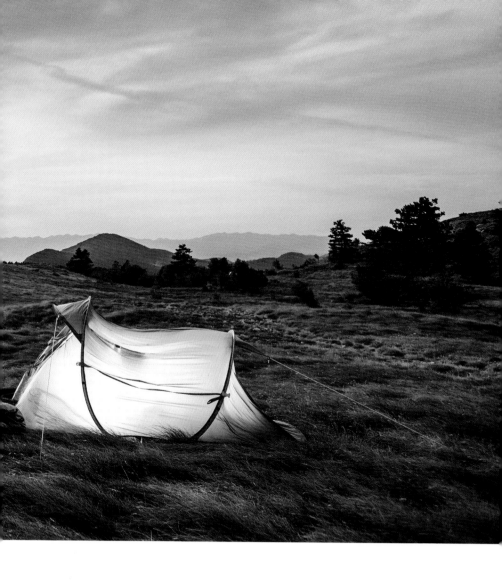

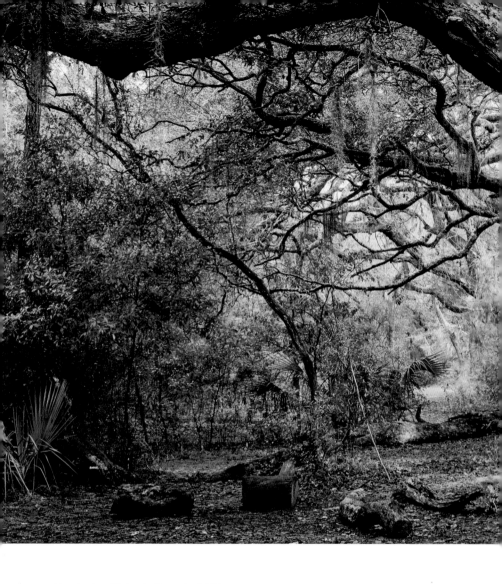

Cumberland Island, Georgia, USA
30.8533° N, 81.4389° W

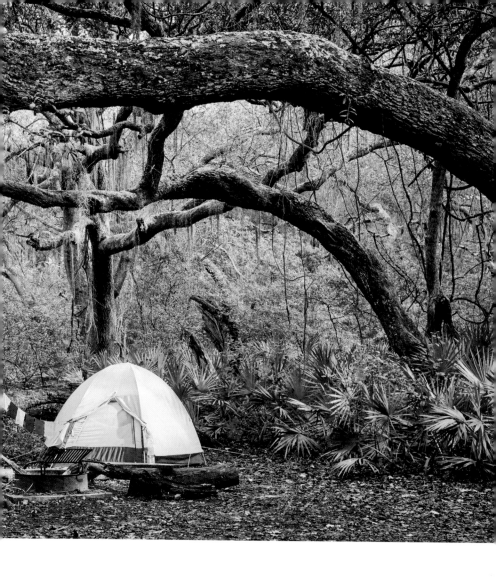

Yosemite National Park, California, USA
37.8651° N, 119.5383° W

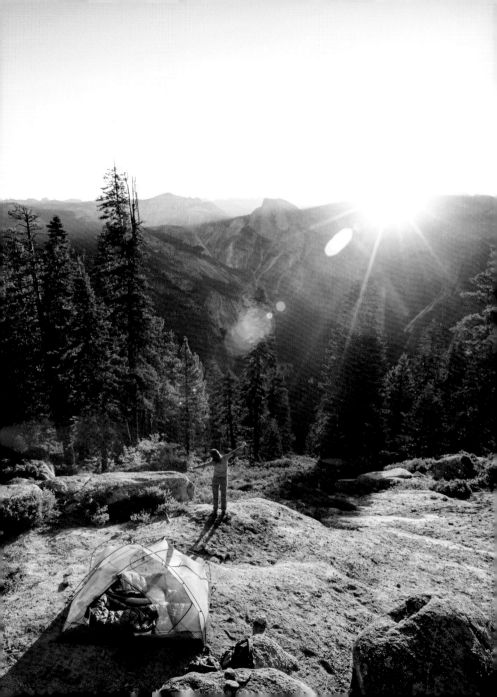

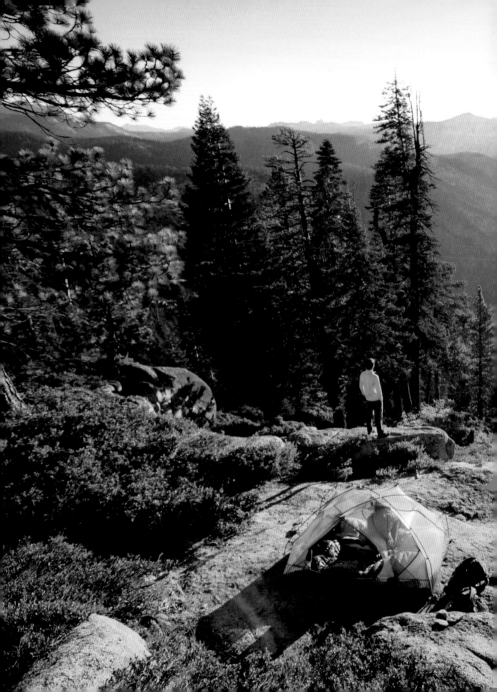

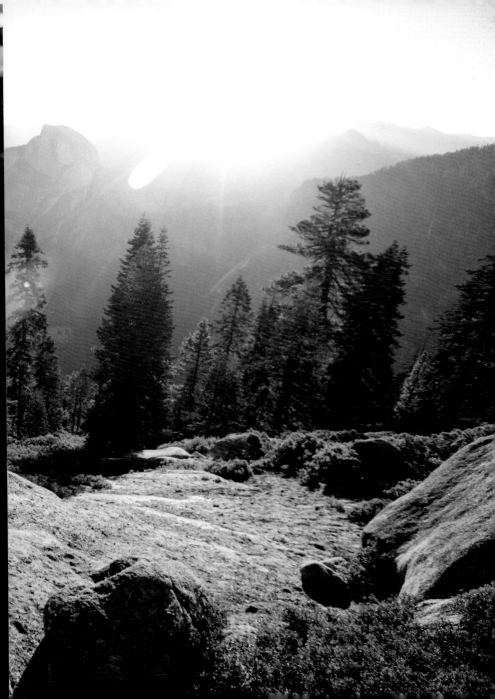

Bellingham, Washington, USA
48.7519° N, 122.4787° W

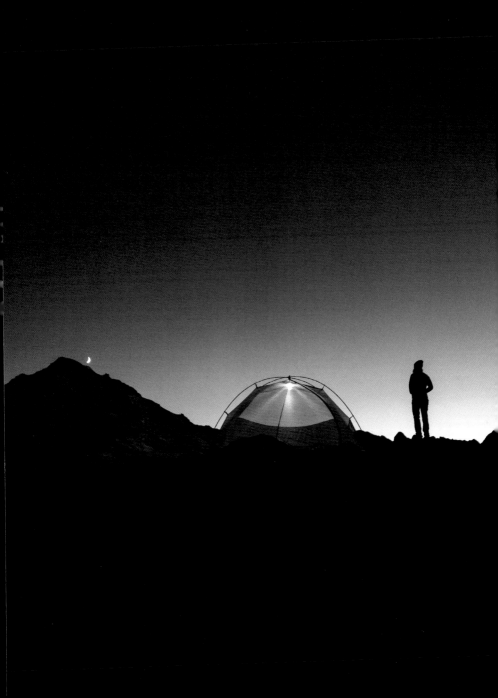

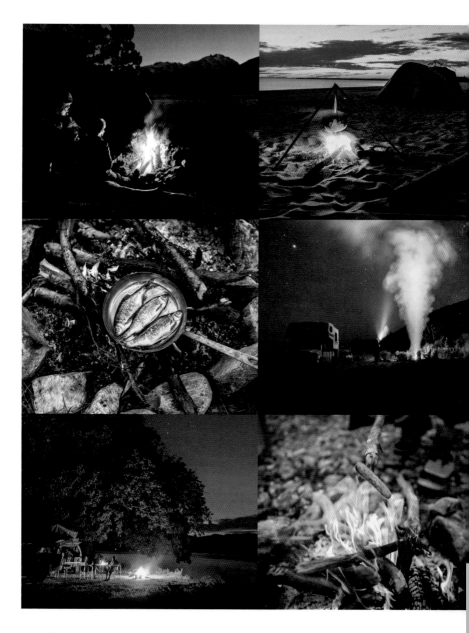

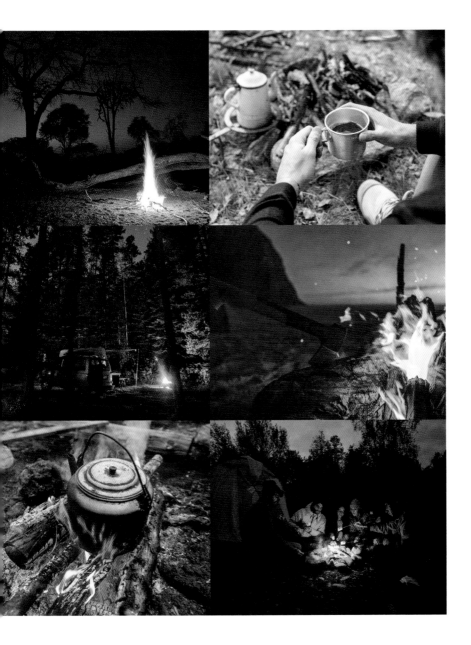

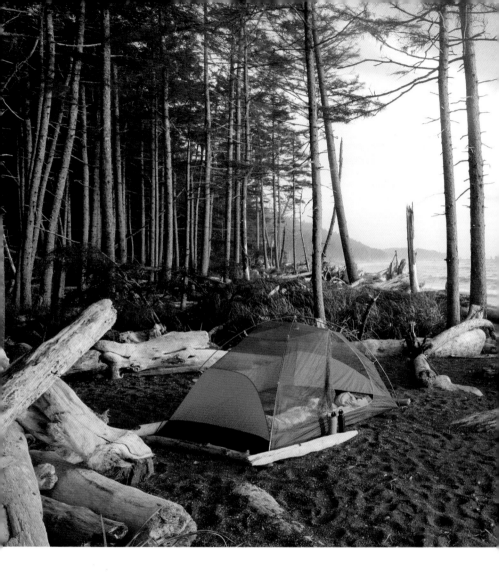

Olympic National Park, Washington, USA
47.8021° N, 123.6044° W

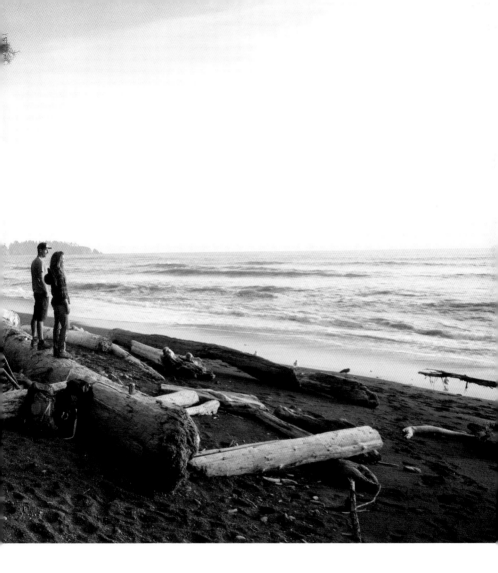

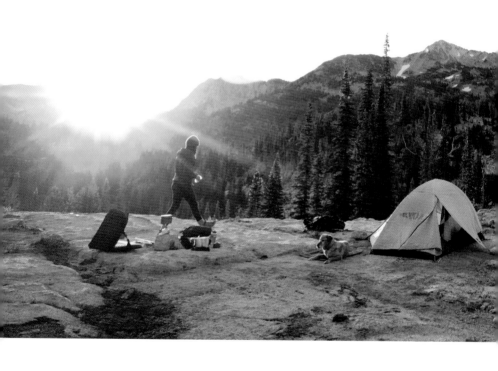

Joseph, Oregon, USA
45.3543° N, 117.2296° W

@JORDAN_SIEMENS

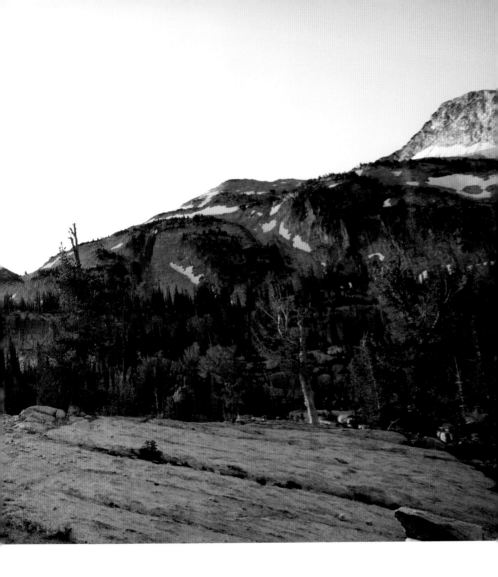

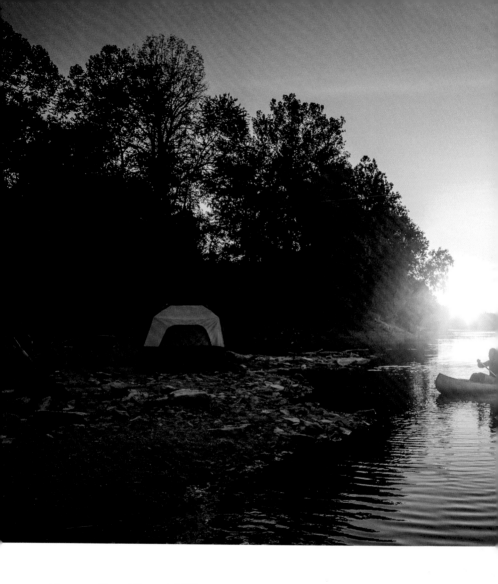

Meramec River, Missouri, USA
38.2855° N, 90.9168° W

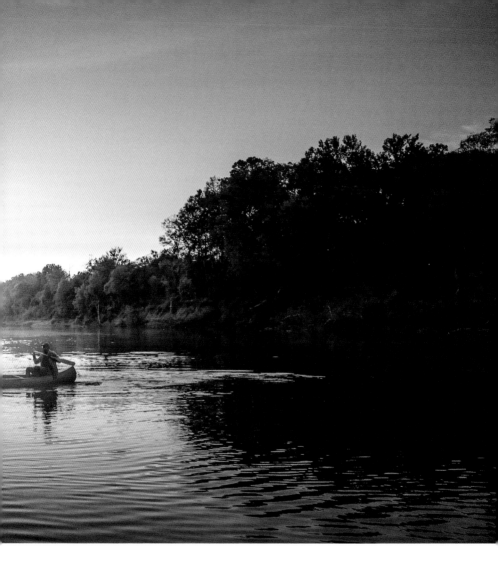

'Give me the splendid, silent sun with all his beams full-dazzling.'

–Walt Whitman

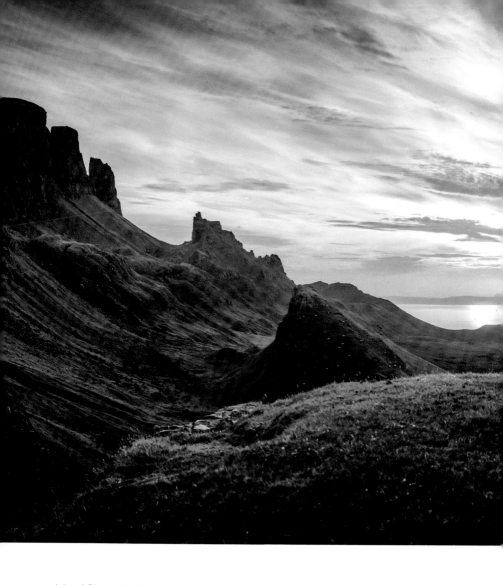

Isle of Skye, Scotland
57.2736° N, 6.2155° W

WILLIAM FAWCETT

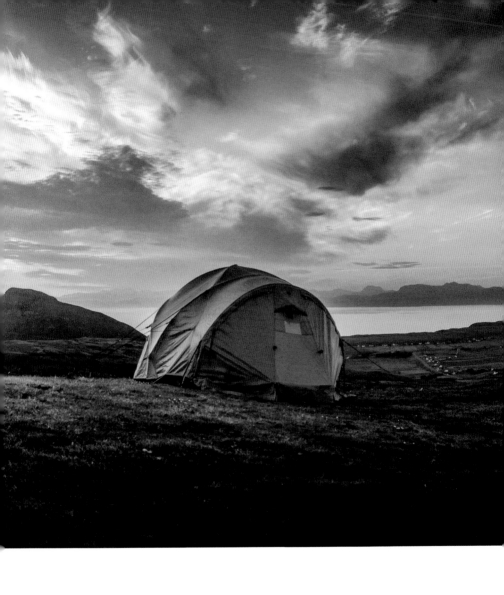

Oregon, USA
43.8041° N, 120.5542° W

WILLIAM FAWCETT

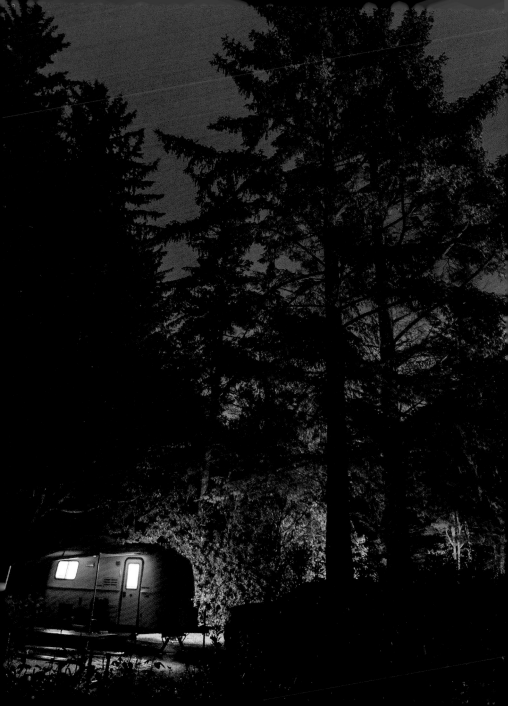

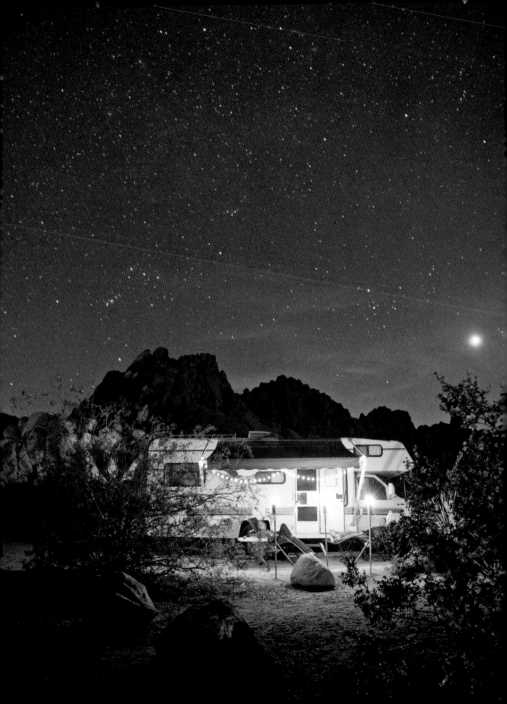

Joshua Tree National Park, California, USA
33.8734° N, 115.9010° W

STEPHEN SIMPSON

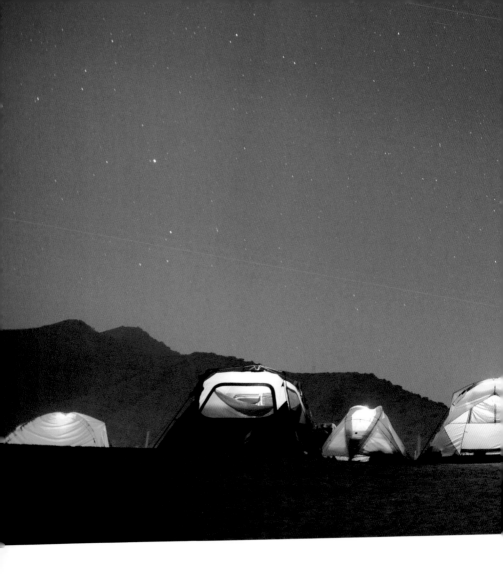

Santa Catalina Island, California, USA
33.3879° N, 118.4163° W

STEPHEN SIMPSON

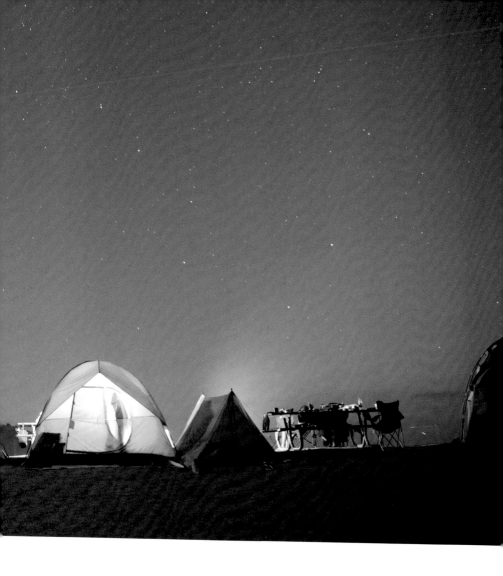

Sea of Cortez, Baja California Sur, Mexico
26.7313° N, 110.7122° W

STEPHEN SIMPSON

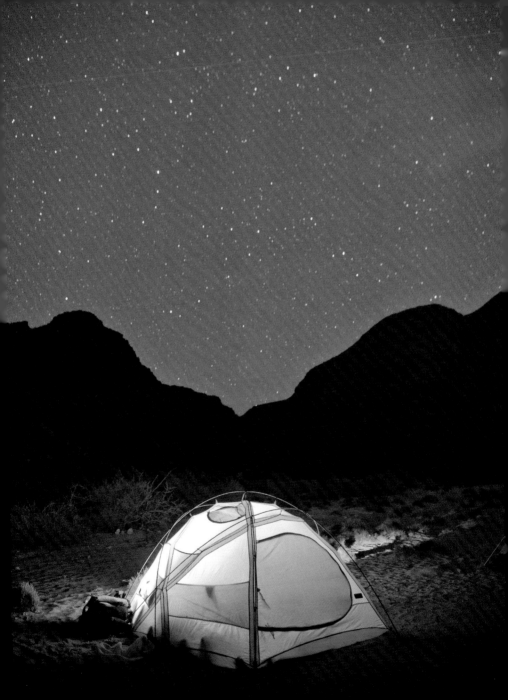

Sea of Cortez, Baja California Sur, Mexico
26.7313° N, 110.7122° W

STEPHEN SIMPSON ·

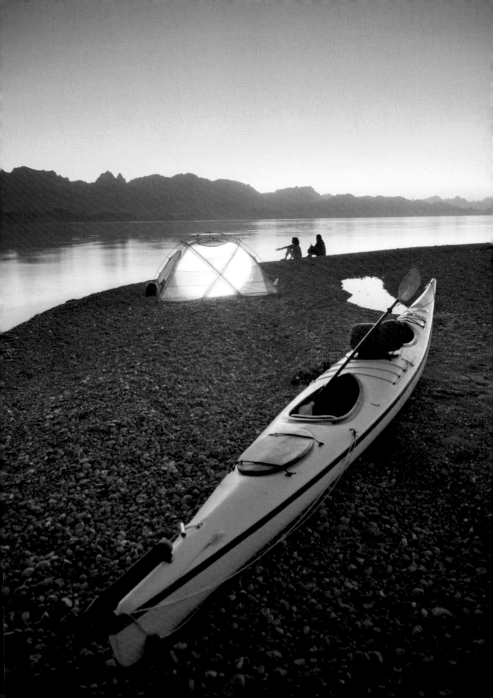

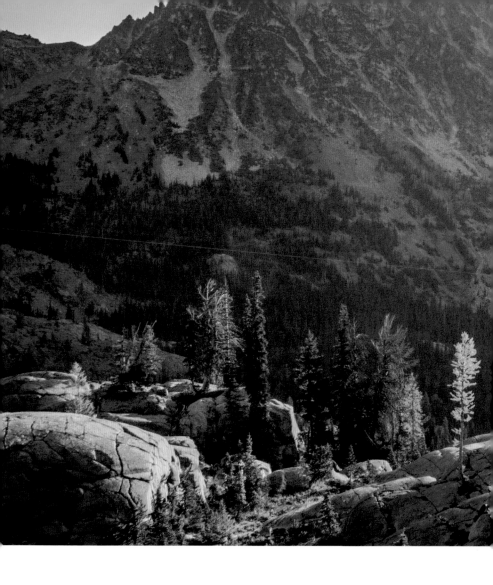

Lake Ingalls, Washington, USA
47.4708° N, 120.9385° W

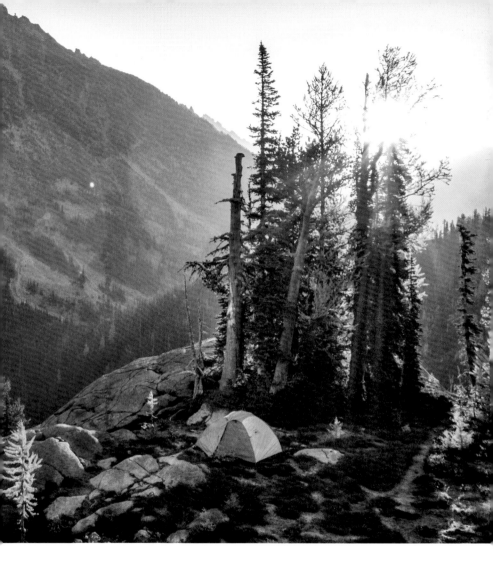

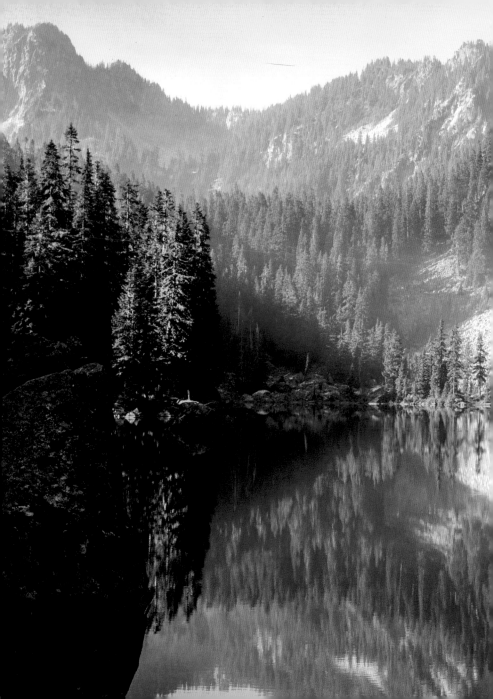

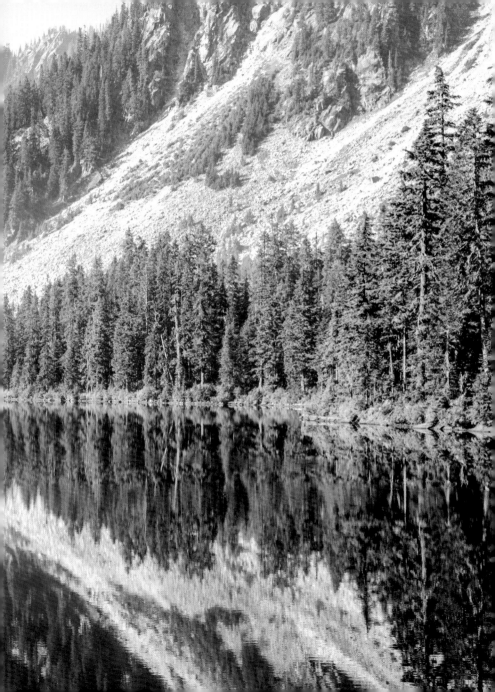

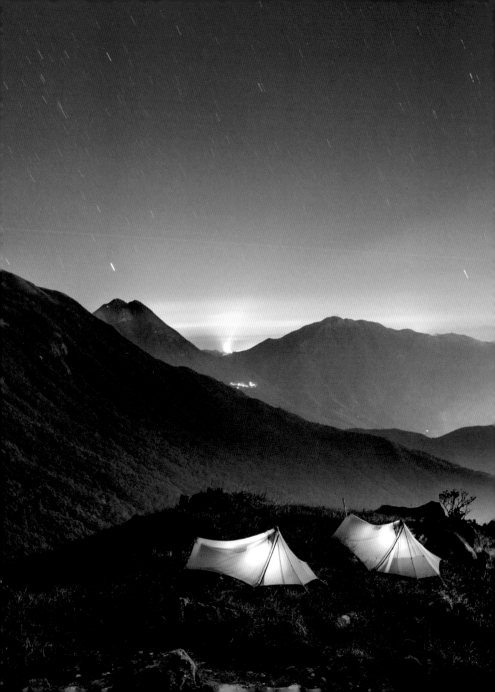

Lantau Island, Hong Kong, China
22.2665° N, 113.9418° E

@ILKLAS

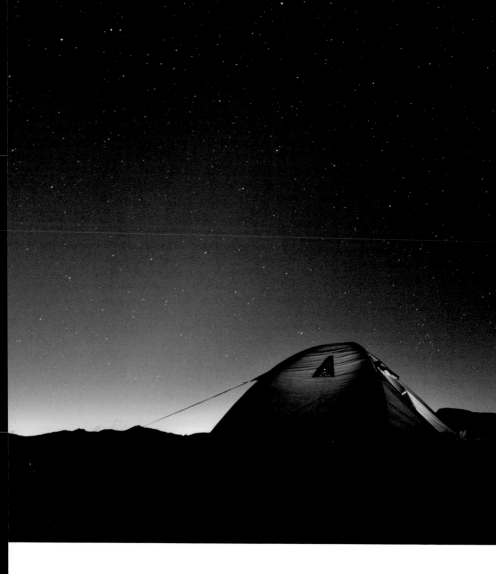

Pella, Northern Cape, South Africa
29.0341° S, 19.1530° E

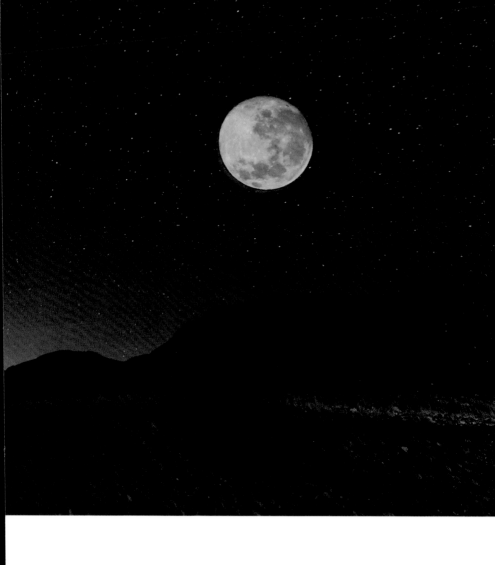

Bourke, New South Wales, Australia
30.0888° S, 145.9378° E

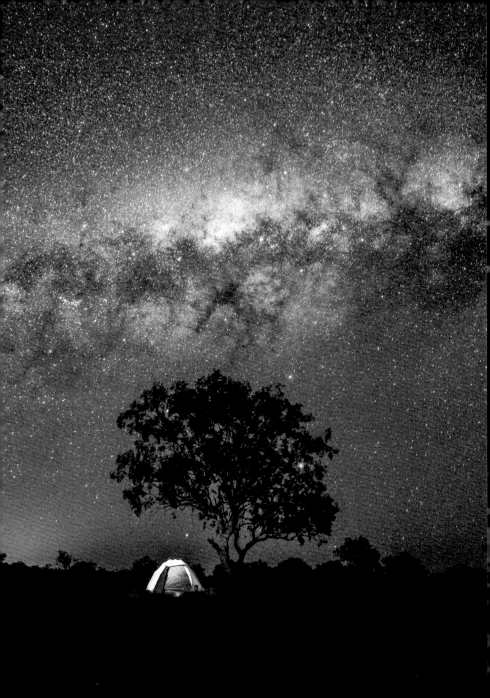

Queensland, Australia
20.9176° S, 142.7028° E

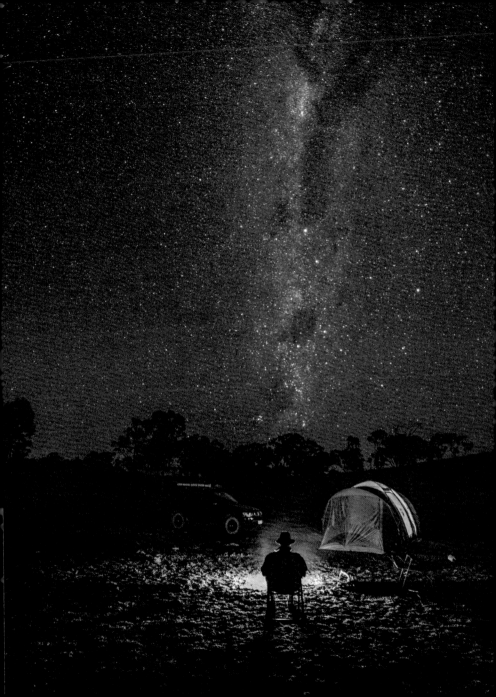

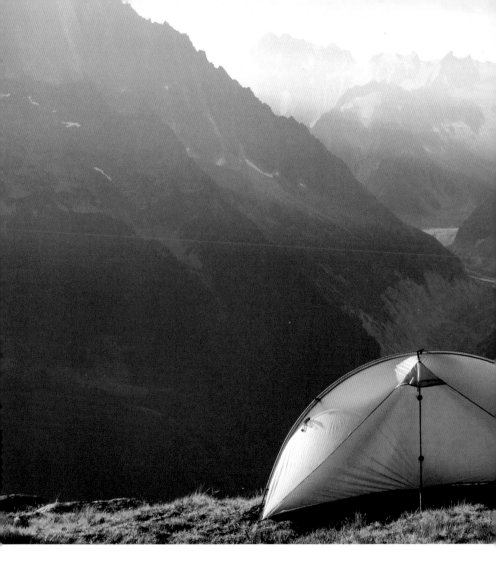

Chamonix, Auvergne-Rhône-Alpes, France
45.9237° N, 6.8694° E

@SANDERVDW

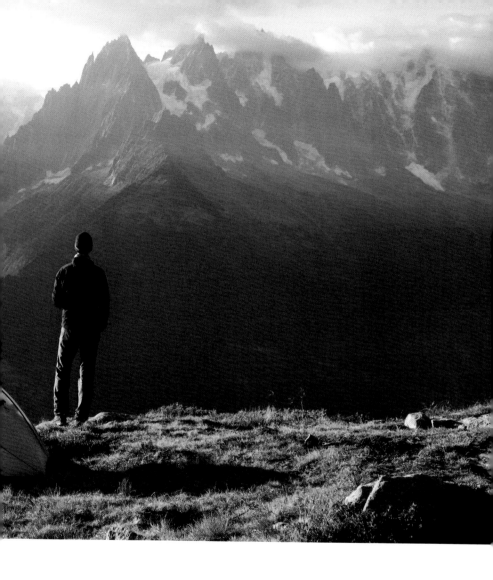

'Earth and sky,
woods and fields,
lakes and rivers,
the mountain and
the sea, are excellent
schoolmasters,
and teach some
of us more than
we can ever learn
from books.'

–John Lubbock

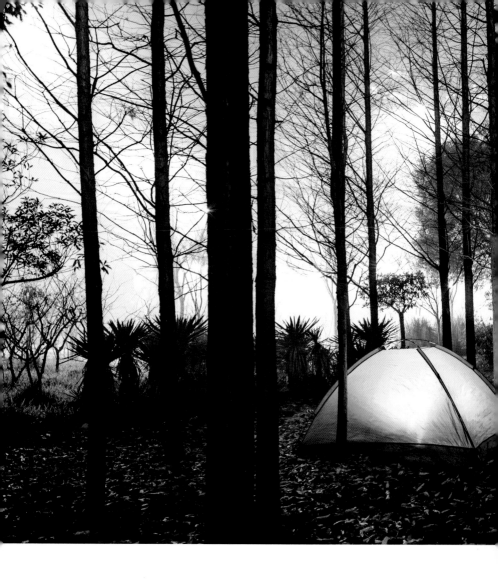

Shanghai, China
31.2304° N, 121.4737° E

WANGWUKONG

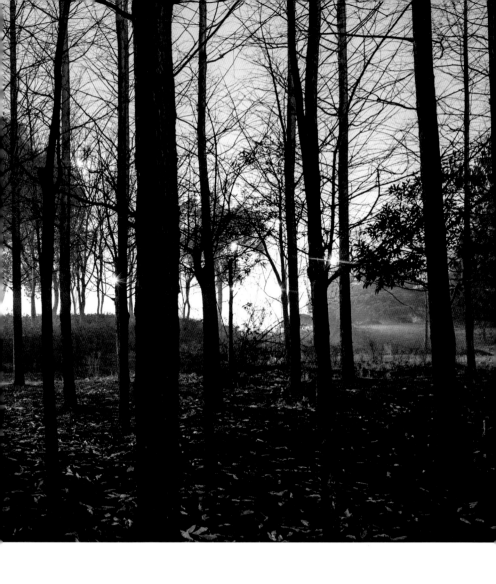

Lukpe Lawo, Gilgit-Baltistan, Pakistan
36.0425° N, 75.6583° E

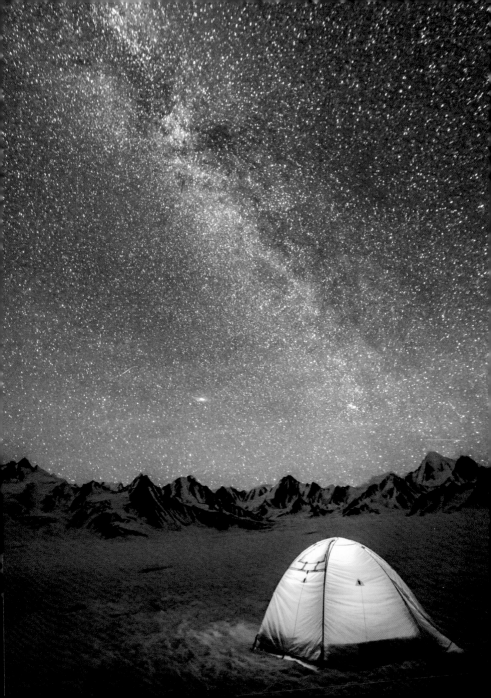

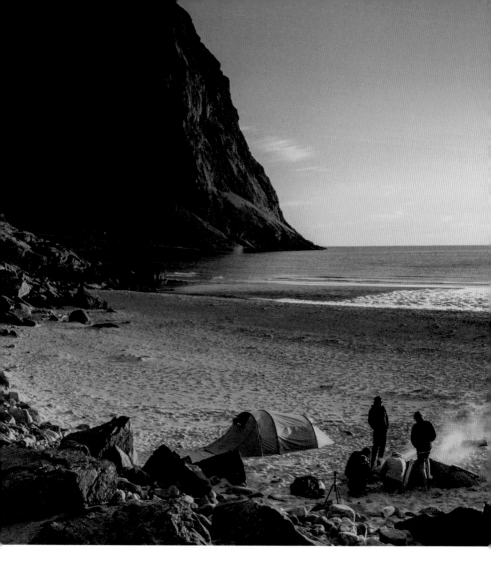

Kvalvika Beach, Lofoten Islands, Norway
68.4711° N, 13.8636° E

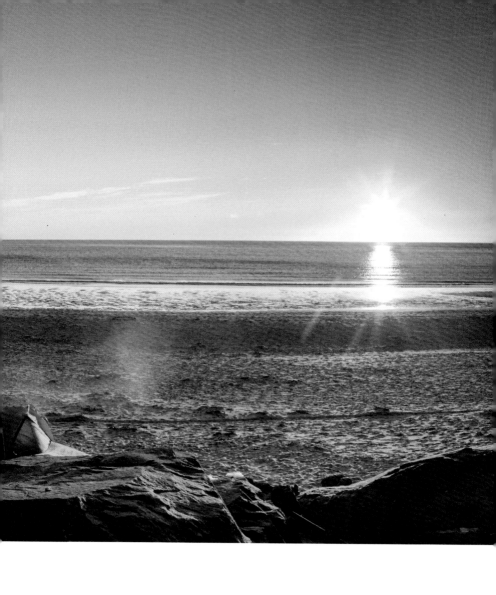

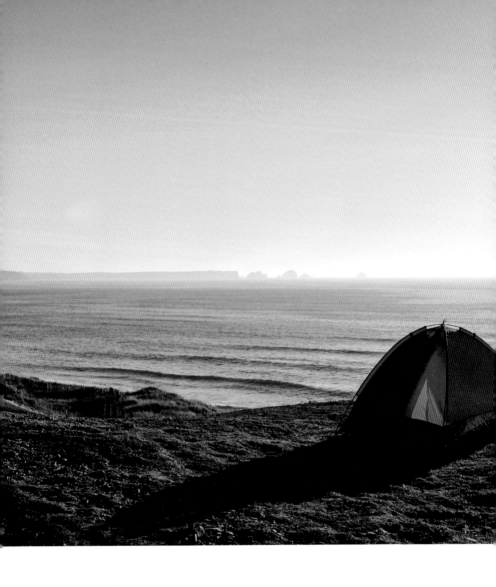

La Palue, Brittany, France
48.2052° N, 4.5440° W

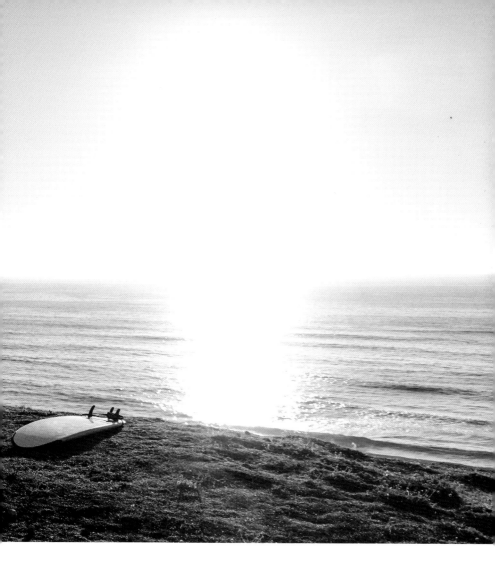

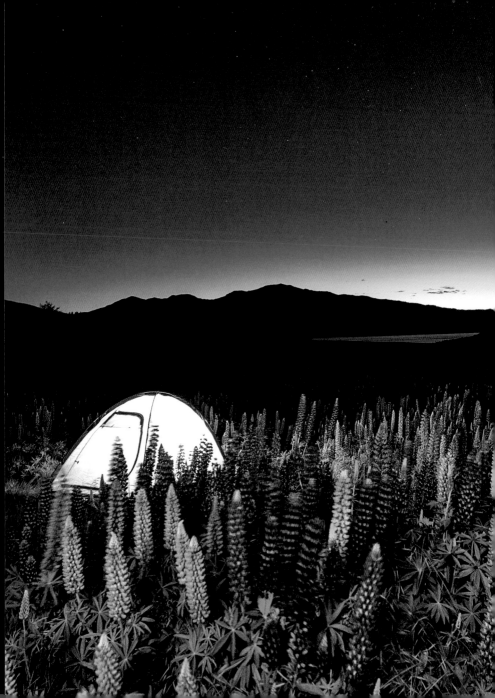

Lake Tekapo, Canterbury, New Zealand
44.0041° S, 170.4762° E

PURIPAT WIRIYAPIPAT

South Base Camp, Mt. Everest, Nepal
28.0008° N, 86.84805° E

SUPHANAT WONGSANUPHAT

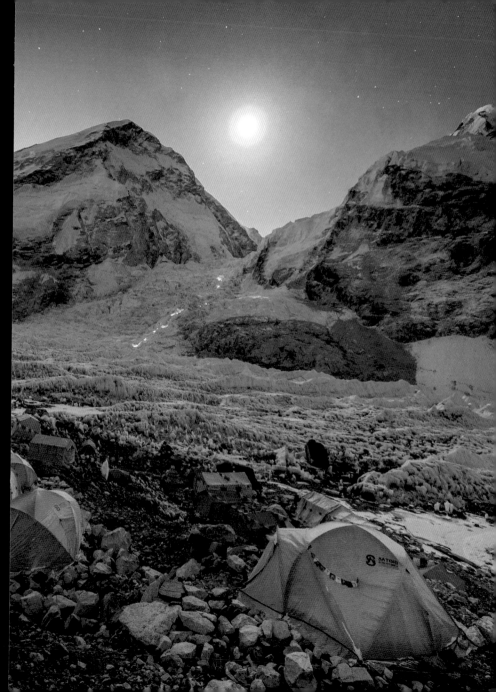

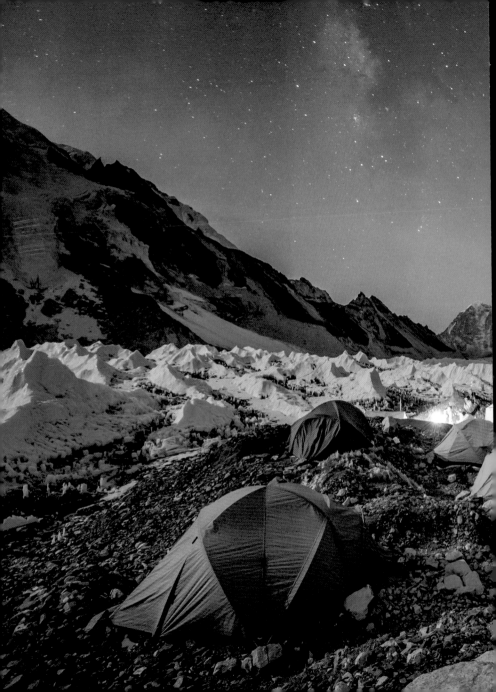

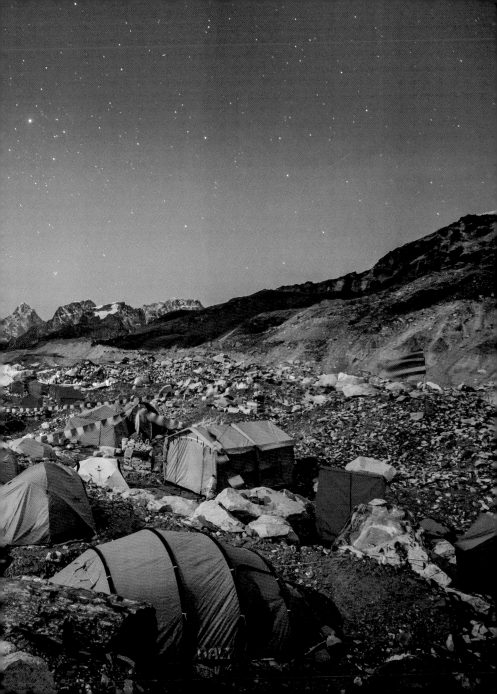

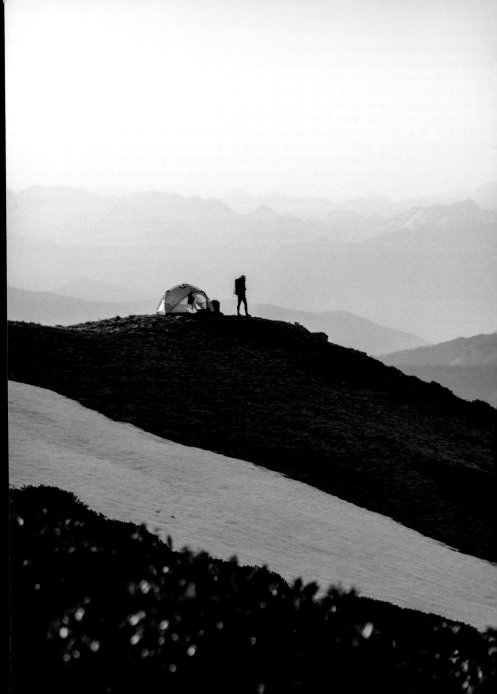

Canton of Ticino, Switzerland
46.3317° N, 8.8005° E

@MILOZANSTUDIO

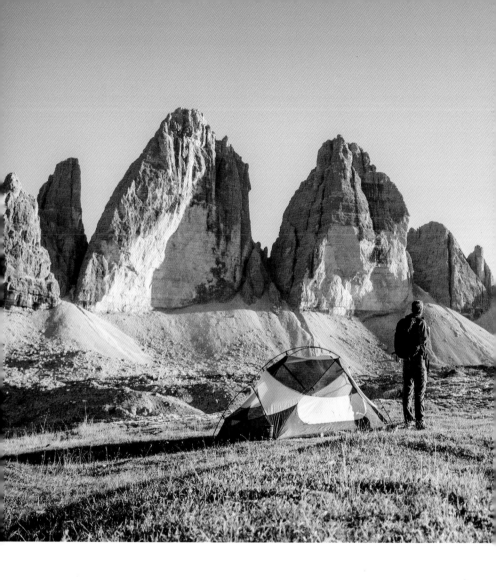

Dolomites, Trentino-South Tyrol, Italy
46.4102° N, 11.8440° E

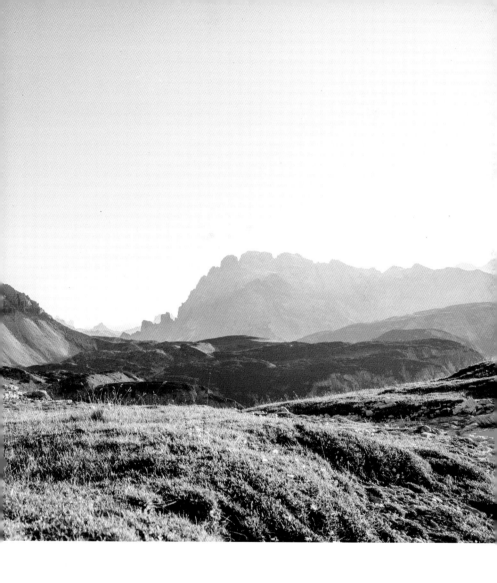

'There was
nowhere to go
but everywhere,
so just keep
on rolling under
the stars.'

–Jack Kerouac

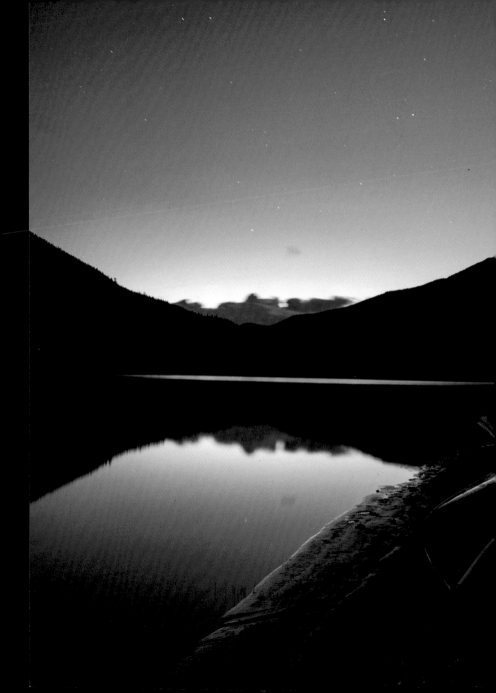

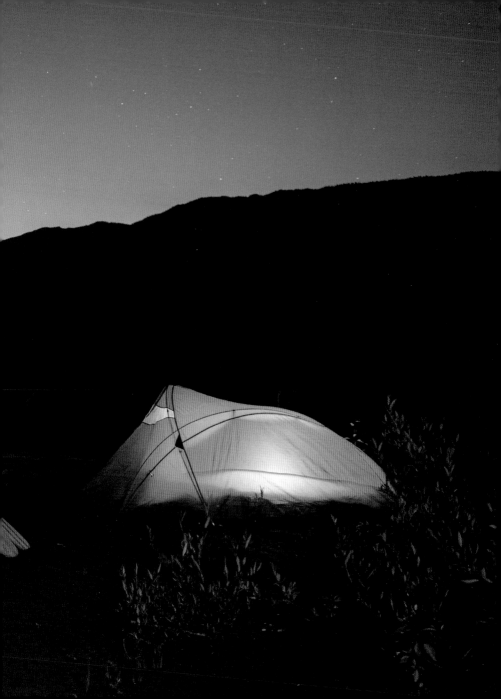

Index by Location

Index by Contributor

First published in the United States of America in 2021 by Chronicle Books LLC.

Produced and originated by Blackwell and Ruth Limited:
Publisher: Geoff Blackwell
Editor in Chief: Ruth Hobday
Design Director: Cameron Gibb
Designer & Production Coordinator: Olivia van Velthooven
Publishing Manager: Nikki Addison
Digital Publishing Manager: Elizabeth Blackwell
www.blackwellandruth.com

The publisher is grateful for literary permissions to reproduce items subject to copyright. Every effort has been made to trace the copyright holders and the publisher apologizes for any unintentional omission. We would be pleased to hear from anyone not acknowledged here and undertake to make all reasonable efforts to include the appropriate acknowledgment in any subsequent editions: p. 5: John Burroughs, *Leaf and Tendril* (Boston, USA: Houghton, Mifflin and Company, 1908); p. 23: Edward Abbey, *Desert Solitaire: A Season in the Wilderness* (New York, USA: Touchstone, a division of Simon & Schuster, Inc., 1990), copyright © 1968 by Edward Abbey, renewed 1996 by Clarke C. Abbey. Reprinted by permission of Don Congdon Associates, Inc.; p. 55: John Muir, *Our National Parks* (Boston, USA: Houghton, Mifflin Harcourt Publishing Company, 1901); p. 89: Daniel J. Rice, *This Side of Wildermess: A Novel* (Livingston, MT, USA: Riverfeet Press Publisher, 2013); p. 121: copyright © Victoria Erickson; p. 155: Walt Whitman, "Give Me the Splendid Silent Sun," *Leaves of Grass* (London, UK: Penguin Classics, an imprint of Penguin Random House, first published in 1855); p. 183: Sir John Lubbock, *The Use of Life* (London, UK: Macmillan and Company, 1894); p. 203: Jack Kerouac, *On the Road* (New York: Viking Books, an imprint of Penguin Publishing Group, a division of Penguin Random House LLC., 1957), copyright © 1955, 1957, by John Sampas, Literary Representative, the Estate of Stella Sampas Kerouac; John Lash, Executor of the Estate of Jan Kerouac; Nancy Bump; and Anthony M. Sampas. Used by permission of Viking Books, an imprint of Penguin Publishing Group, a division of Penguin Random House LLC. All rights reserved.

Library of Congress Cataloging-in-Publication Data available.

ISBN 978-1-7972-0785-8

Chronicle Books LLC
680 Second Street, San Francisco, CA 94107
www.chroniclebooks.com

10 9 8 7 6 5 4 3 2 1

Captions

Front cover:
Bourke, New South Wales, Australia
30.0888° S, 145.9378° E
@troodphoto

Front endpaper:
Carpathian Mountains, Ukraine
47.2390° N, 25.5909° E
@olehslobodeniuk

Pages 2–3:
Mount Pilatus, Lucerne, Switzerland
46.9795° N, 8.2548° E
@robin.stamm

Pages 204–5:
Cheakamus River,
British Columbia, Canada
49.7817° N, 123.1785° W
@mikecranephotography

Back endpaper:
Torbeyevskoye Lake,
Moscow Oblast, Russia
56.3333° N, 38.2667° E
@westend61

Back cover:
Dolomites, Trentino-South Tyrol, Italy
46.4102° N, 11.8440° E
@evgeniybiletskiy

Printed and bound in China by
1010 Printing Ltd.

This book is made with FSC®-certified paper and other controlled material and is printed with soy vegetable inks. The Forest Stewardship Council® (FSC®) is a global, not-for-profit organization dedicated to the promotion of responsible forest management worldwide to meet the social, ecological, and economic rights and needs of the present generation without compromising those of future generations.

MIX
Paper from
responsible sources
FSC® C016973